DIGITAL PHOTOGRAPHY WORKSHOPS

PORTRAITS

A RotoVision Book
Published and distributed by RotoVision SA
Route Suisse 9
CH-1295 Mies
Switzerland

RotoVision SA
Sales & Editorial Office
Sheridan House, 114 Western Road
Hove BN3 1DD, UK

Tel: +44 (0)1273 72 72 68
Fax: +44 (0)1273 72 72 69
Email: sales@rotovision.com
Web: www.rotovision.com

10 9 8 7 6 5 4 3 2 1

ISBN 2-940361-09-6

Art Director Tony Seddon
Book design Lanaway

Reprographics in Singapore by
ProVision Pte. Ltd.
Tel: +656 334 7720
Fax: +656 334 7721

Printed and bound in Singapore by Star Standard PTE Ltd.

DIGITAL PHOTOGRAPHY WORKSHOPS

PORTRAITS

A UNIQUE COURSE IN A BOOK TAKING YOU
FROM BEGINNER TO EXPERT

RotoVision

CONTENTS

1 GETTING STARTED

New to digital, or familiar, but need bringing up to speed? These are the digital essentials, including cameras, lenses, software, and a digital photography primer.

2 WORKING WITH YOUR SUBJECT

Learn the right from the wrong way to pose people in pictures, how to catch subjects offguard for candid moments, how to get them to express themselves, what you can gain from shooting sequences, and where you can actually find subjects when your friends refuse.

3 PORTRAIT TYPES

Discover what effect the length of the portrait has on how you can light it and how the subject can pose. From the simplicity of head-and-shoulder shots to the challenge of making sure a full-length pose doesn't look awkward and is lit properly. Shoot a formal study, or let rip with an informally styled shoot. Then throw in props and learn how to use them, along with the shapes that come with group photography.

4 LOCATION SHOOTS

The challenges and rewards of shooting on location are examined and explained in this chapter, from managing the situation in urban locations to searching for attractive backdrops in rural beauty spots. The challenges range from unpredictable sunshine and lighting conditions to the advantages of having the space and freedom to shoot at whatever length and using whatever creative settings you desire.

5 LIGHTING STYLES

There's no doubt about it, the ability to control and use lighting well—whether it's electronic flash or tungsten lamps in the studio, or the soft light from a window—is what will set your photos apart from anyone else's. Here we look at how to use lighting in the studio, from simple setups to more complex arrangements, and challenge you to use filtered daylight through a window to convincing effect.

6 IMAGE EDITING

Capturing the digital photo is only the start of the process of producing the final picture. It's a rare event if it's ready to go straight out of the can, so expect to tweak, improve, correct, and enhance your images on computer.

7 STORE, PRINT, PUBLISH

As digital photos are digital files, you must familiarize yourself with file formats to optimize your storage against quality considerations. Then it's the world of color management and printing images yourself, before you finally move on to uploading photos to the Web and sending them to relatives by e-mail.

8 APPENDIX

INTRODUCTION

This book is about portraits: how to compose, model, and light them. Portraits are one of the most popular photographic subjects. However, to lift your people pictures above the level of mere snapshots, you need an understanding of poses, composition, lighting, and digital camera lenswork. That's where the workshop element of this book comes into play, because for each type of shot there's a lighting or compositional guide, showing how it was set up. For every photo that's successful, there are often ones that are not. We show some near-misses alongside the winning entries.

In each chapter you will be issued with challenges. For these you need to put your creative hat on, whether you're shooting for a mall photographer, an agency, advertising clients, or for aspiring models and actors wanting portfolio shots. We give you the brief, show how to set it up, explain how we did our interpretation, and challenge you to do it just as well—or better. At the end of the main chapters we have a selection of photos from a variety of contributors, showing great photos in each of these fields.

However, we begin our guide to the world of digital portraits with a Getting Started chapter. This covers the basics you need to know about digital cameras, the type and quality of camera that you will need, essential accessories, lenses, and the all-important post-production element of using the right software to enhance your images. Then it's into the nitty gritty, as we explain how to lead the subject to produce poses that are effective and creative. See what you can do when you catch your subject offguard or shoot a series of images, and, most importantly, where you can go to find subjects to photograph.

The length that you shoot a portrait, from head and shoulders, to a full-length body shot, determines how the subject is posed, what you can do with lighting, whether props need to be used, and the length of lens that is advisable. In Chapter 3 there is a range of portrait length types, showing what each has to offer, the problems, and how to get around them. Then we tackle formal and informal settings, groups, and families.

Shooting on location offers a different challenge from studio or interior work. From crowd control to the weather, the problems are varied and will put the best photographer to the test. However, urban and rural settings offer myriad photographic locations and we

have a look at some of the various places you can go to shoot. The sun itself plays a huge part in location photography, from changing color, through harsh midday light, to overcast days when the light is ideal for shadowless portraits. When outdoors, you can use the location to tell a story or to shoot action pictures of people involved in sporting events, and control the shutter speed and aperture for creative effect, rather than just a straightforward record of the event.

However, it is light and how you use it that is the critical element in successful portrait photography. Whether it's twin flash heads to cover a scene with even light, or a creative arrangement of three or more lights, making

areas of light and dark, teasing shadows, and shimmering highlights, if you can master lighting you can create effective pictures with the simplest of elements. If you have professional lights, use the diagrams to help you set up the shot. If you are using domestic lights, substitute a floor-light with a diffusing shade for the softbox in the diagrams, and a domestic spotlight for the professional counterparts in the diagrams.

Digital cameras are their own mini-labs, producing the picture in-camera, but with digital the story doesn't end there. Consider the image from the camera as the starting point, and use software to develop it further, enhancing detail and colors, correcting mistakes that you didn't spot at the time, or using the powerful functions on offer to create radical visions based on the original image. Remember, with digital you shoot color; turning it into black and white is best done on the computer where you have total control over the process.

We finish off *DPW: Portraits* with a look at how to store your digital files, color management, and printing, then archiving them or the Web, or sending by e-mail. We hope that you'll learn, enjoy, and be inspired as you work your way through the book to create your own fantastic, digital portraits.

Duncan Evans, LRPS
www.duncanevans.co.uk

1 GETTING STARTED

Whether you're a newcomer to photography or a film user making the change, digital photography can be a very confusing place, full of jargon and strange technology. The good news is that it still is, at the end of the day, simply photography. The technical process may be different, and the accessories bewildering for some users, but it's still a camera with a lens, using shutter speed and aperture to capture the exposure. In this chapter we explain all the other stuff surrounding those basic facts.

▲ What goes on inside digital cameras and how can the technology be made to work for you? This book is a digital photography primer.

▲ Which camera do you need, or want, and what are the advantages and disadvantages of compact and SLR digital cameras?

▲ Batteries are essential accessories that you can't live without in the digital world.

▲ What is a prime lens and why is it better than a zoom lens that covers all options? Find out on page 18.

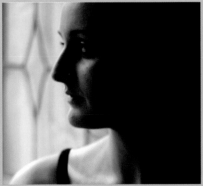

▲ What's the best software for your digital photography? Do you really need to splash the cash?

THE DIGITAL ADVANTAGE

It's no surprise that in this technological age digital camera sales should completely outstrip those of film cameras. With the performance and pixel count ever rising, compared with prices that have dropped dramatically in recent years, the digital camera owner now has a camera and developing lab, all in one small package, with files that can be readily improved, tweaked, corrected, saved, printed, and e-mailed to friends and family around the world.

LEARNING THE ROPES

The problem for anyone starting out in photography used to be that the time delay between taking the picture and actually seeing it meant that what you did, what the conditions were like, and how you shot it were all forgotten. If the photo was poor, there was little understanding of why that should be so, and no chance to learn by the mistake and reshoot for a successful photo. That is digital's big advantage for those learning photography—the result can be checked, the lesson can be learned, and corrective measures can be taken.

INSIDE THE BOX

Inside each digital camera is either a Charge Coupled Device (CCD) or a CMOS (Complementary Metal Oxide Semiconductor) chip. On the chip are light-sensitive diodes that register incoming light photons and, at a certain point, trigger a charge that the processing brain of the camera interprets as a value of light and registers as a picture element, or individual pixel in the digital

▲ The Fujifilm SuperCCD SR chip layout, with two light-receptive cells at each pixel location.

image. The more pixels there are, the more detailed the image. This is commonly referred to in terms of millions of pixels (the width multiplied by the height of the image), or in short form, Megapixels or Mp.

Color generation, on the other hand, is more of an arcane science. A color matrix is overlaid on the chip and consists of red, blue, and two green elements, per four diodes. This means that red and blue detection is only 25% accurate and green is 50%. Then algorithms in the camera's firmware assess whether the picture is a portrait, or a landscape with green land and blue sky, and changes those results that are false. In many respects, it is the cleverness of the firmware that determines how accurate the color rendition is, not the quality of the lens. Recent chip developments have added extra elements to the color matrix, and one chip manufacturer notably introduced a system whereby there are actually three layers, each dedicated to a single color, which should make color rendition much more accurate.

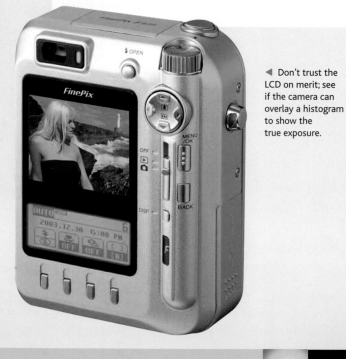

◄ Don't trust the LCD on merit; see if the camera can overlay a histogram to show the true exposure.

BRIGHT IDEA

Don't trust the LCD on playback; it is designed to show a bright, colorful image that may not be accurate. If your camera can produce a histogram, use that function to see the spread of tones—this is much more accurate.

DIGITAL ISO

Film is rated according to how fast the individual elements of chemical grain in it react to light. The faster the film stock, the higher the ISO rating, but also the larger the grain. So, very fast film of say ISO 1600 and ISO 3200 tends to be quite grainy, which is very pleasing in black and white photography, but less so in color.

Digital doesn't have reactive chemicals of course, but it does have ISO ratings. This is because the ISO rating is set according to the amount of time that light is allowed to build up in the photodiodes on the camera CCD/CMOS. The longer the time, the more accurate the light reading, which is standardized at ISO 100. When using shorter times, the ISO rating increases to typically ISO 800, though some cameras have ISO 1600 and higher. The trouble is that because the time allowed for light to collect is now relatively short, it is considerably less accurate. This results in errors in the form of odd-colored pixels (known as noise) appearing in the photo, which is highly unpleasant, and may, depending on the camera, give an entirely unacceptable result.

The digital advantage is that each and every shot can use a different ISO setting. So, if you were photographing a church from the outside, you would use ISO 100, but if you then went inside and didn't have a tripod, because the light is much lower you might want to increase the ISO to 400 to ensure that camera shake didn't ensue.

▶ You can set the digital ISO either in a menu setting on a compact camera, or on a dial on a camera like this Fuji S3 Pro.

COLOR SPACES

Many digital cameras come with a choice of two color space profiles. One is sRGB and the other is AdobeRGB 1998. The latter has a wider color gamut, which means it has more colors. You should use this if your work is mainly for printing. If you intend to upload images to the internet on the other hand, the sRGB profile represents a safer spread of colors that is more compatible with a wider range of systems. Also, if you are involved in commercial printing, it is better to use sRGB because, when converting to the CMYK model that is used for commercial presses, there are fewer colors that will be out of gamut. CMYK has a much narrower gamut than RGB, so it makes sense to reign them in initially.

TOP TIP

Ensure that your camera produces enough pixels for what you need. If you're also involved in landscapes, go for 8Mp or more, but for portraits 5Mp or 6Mp is plenty.

◀ Photoshop can be set up to use color profiles for either RGB or CMYK, converting from whatever the file was using to the working profile.

YOUR CAMERA: BEST VERSUS BUDGET

When starting out shooting portraits digitally, it can be tempting just to buy the cheapest camera you can find. While this is admirably frugal, and digital compacts offer a lot of performance for the price, if you intend to take photography more seriously, it can prove a false economy. That said, amazing results can be achieved with cheap and cheerful cameras, but you will have to work harder to get the right results.

COMPACT DIGITALS

There are advantages to the digital compact, not least that it's small and unobtrusive. It can easily be carried around and produced when a shot presents itself. Also, if shooting candid photos of strangers, then the combination of small size and large zoom can capture those moments without attracting unwanted attention.

One of the disadvantages of using a compact is that even on well-featured models, the lens performance is restrictive and that you are largely stuck with what was built-in. The aperture range is usually f/2.8 to f/8, but even f/2.8 on a compact gives a depth of field more equivalent to f/11 on an SLR. That makes it much more difficult to get the background out of focus—the most basic technique in portraiture.

The good news is that compact digitals are now very affordable, offering power and resolution unheard of just three years ago. Even in this category there is a range of models, from a basic point-and-shoot with a plastic exterior, to a more fully functional, prosumer compact, with total photographic control and a raft of advanced functions. For shooting portraits you want a camera with at least a 5Mp resolution, and even cheap models can manage that these days.

Before splashing the cash, it is worth looking at the aperture range, the available ISOs, and the lens zoom range. Some compacts offer aperture as wide as f/1.8, which both makes it easier to shoot backgrounds out of focus and is more responsive in low light. A range of ISOs from 50 to 800 will give you a good choice between quality and increased shutter speed. The zoom range, though, is usually, but not always, referred to in terms of a multiplying factor, such as a 5x or a 7x zoom. However, bear in mind that this is the range multiplied by the widest angle. If the wide-angle end is 36mm equivalent, then a 5x zoom gives a telephoto reach of 180mm equivalent. If the wide-angle end is 28mm, though, then a 5x zoom gives a telephoto of 140mm, much shorter in other words. It is recommended that you buy a compact with a wide-angle of 28mm equivalent, because, while you won't use it all the time for portraits, it can be used to great creative effect and is very useful for getting all the detail in view on interior shots.

▲ The Nikon CoolPix 7900 digital compact offers high spec for little money.

BRIGHT IDEA
If your budget can only stretch to a compact with a motorized zoom, you can still shoot some brilliant portraits: zoom right in on your subject so their face fills the frame, and knock the background out of focus.

▼ The Nikon D2X is a fast and sturdy press and professional digital SLR, designed for use in the field.

DIGITAL SLRS

The digital Single Lens Reflex camera works on similar principles to the film SLR, though it obviously has the advantages of variable ISO ratings for every shot, LCD playback to check the exposure, and the ability to shoot however many pictures your memory card can store, at no extra cost. The big difference between the SLR and the compact is that it uses interchangeable lenses, so that you can switch lens to shoot specific creative effects. You can buy extra lenses as and when you can afford it.

The difference between using an SLR and a compact is significant. You have access to the full range of apertures, the image quality is better, the cameras can shoot more hi-res pictures, faster, and the handling is infinitely better. It is also easier to connect to studio flash equipment. For this your camera either needs to be equipped with a PC sync socket, or you will need a hotshoe adapter that either fires infrared signals to the lights or offers a PC sync socket itself.

The differences between low-cost digital SLRs and professional models tend to be ones of image resolution, shooting speed, or significantly increased build quality. Most digital SLRs use a CCD/CMOS chip that is smaller than a piece of 35mm film—the cameras that feature a so-called full-size chip are very expensive. The significance of this is that the chip is in the same place that the film would be, so only the center of the lens is used. This gives an effective focal range shift of around 1.5x. It means that the standard 28mm wide-angle lens actually gives a field of view of 42mm. You will need a lens of 18mm to get even a reasonable 27mm wide-angle. However, at the other end of the spectrum, it's an advantage—the 300mm lens actually gives the reach of a 450mm lens.

▼ The Nikon D50 is an affordable digital SLR, taking a full range of Nikon f-mount lenses.

TOP TIP
The key to buying a camera is to check that it has the functions and the technical characteristics to manage the types of portrait you want to shoot.

15

ESSENTIAL ACCESSORIES

It's a fact of photographic life that your camera purchase is just the start of the spending you will incur with a digital camera. However, with a little thought, the expense can be kept to reasonable levels, though it really does depend on what type of portrait photography you are interested in and how seriously you pursue it.

BASIC PURCHASE

Compact or SLR, the most basic accessory required by everyone is battery power. On a compact camera this may be a proprietary NiCad unit, which needs to be charged with a special battery charger. In this case you are advised to buy a second battery, charge it, and have it spare in your camera bag. For lots of compacts and virtually all SLRs, you use AA-size batteries. Whatever you do, don't put ordinary batteries into the camera as they won't last five minutes. As well as powering the camera, the batteries are used to run the firmware that develops the raw picture and saves it onto the memory card. Digital cameras are very power consumptive. What you need are high-performance Ni-MH (Nickel Metal Hydride) batteries that are rechargeable, so that you can reuse them. Look for 1800MH power batteries or better and always have one spare set in the camera bag.

MEMORY CARDS

After power has been taken care of, it's to the other end of the spectrum, with the storage medium for the pictures. Some cheap cameras have a built-in memory function, but this makes life more difficult. A removable memory card, and there are many formats—CompactFlash II, Memory Stick, x-D Picture Disc, SecureDate (SD)—is your best option. To shoot on maximum quality in TIFF or RAW mode takes up much more space on a card than JPEG. If you are shooting primarily TIFFs then you will need a 1Mb card. If shooting JPEGs at the highest quality setting, then a 512Mb will suffice for an enthusiast, and 256Mb for a more casual snapper. If you are going away somewhere and there is no option to download the pictures from the card, you will need as many cards as you can afford.

BRIGHT IDEA
Cheap, portable studio lighting is available that can be packed up and taken to locations with a power supply. If shooting outside, consider investing in a portable power pack.

DOWNLOADING

The whole point about memory cards is that you can change them in and
out of the camera, and use more than one at a time. When you get back
to the computer, it's awkward to have to wire the camera up to the
computer. Instead, what you need is an inexpensive memory card reader.
These are now either USB or Firewire, are permanently connected to your
computer, and all you have to do is insert a memory card and copy the
contents from a window to your hard drive. If on location, you can still be
shooting with the camera while a PC Card is used, moving pictures from
a memory card to a laptop.

FILTERS

While some compact cameras do come with lens attachments so that they
can use filters, it is really the SLR where filters come into their own. Lenses
tend to have different size rings, so a range of adapters is required to fit on
the filter holder. The adapters are cheap—just get one for each size of lens.
Then look for Neutral Density filters, to block out light, or graduated ones
that can help balance an exposure if the sky is bright or the ground reflective.
A polarizer filter will darken colors on a digital SLR and also enhance reflections,
or cut them out entirely, depending on which way it is orientated—they are
circular. There are also other filters worth looking at for specific
circumstances, but those three are essential.

> **TOP TIP**
> To recharge your batteries you'll
> need a recharger. Get one that
> recharges quickly, rather than
> overnight, so that you can be back
> up running with power as soon
> as possible.

LENSES

It's tempting to think, when you are starting out with a digital SLR, that one superzoom lens, a 28–300mm, will do for all situations. Unfortunately, nothing could be further from the truth. Every lens has its day, and if you want to achieve the creative effect you are looking for, then the right lens has to be selected.

> **TOP TIP**
> The prime lens is the one to turn to in low light conditions. With a much wider aperture, you can get faster shutter speeds than using a wide-angle zoom lens.

▶ This unusual shot was taken at ISO 1600 using a "Night" preset, flash, and a 28–110mm lens, zoomed in from about 8 feet (2.5m) away to blur the background. Photo: Chris Middleton.

BRIGHT IDEA
Building up a collection of lenses can be expensive, but there is a thriving second-hand market for them. Check out eBay, the online auction house, for bargains.

PRIMES AND ZOOMS

A prime lens is one that has a fixed focal length, while a zoom is one that goes through a range of focal lengths. To the uninitiated, a zoom would appear to win every time, but there are a number of reasons why prime lenses are in fact superior. The first is that the image quality is better. It tends to have greater contrast and a sharper image. In portraits this is not as important as it is in landscapes, but the quality at the end of a 28–300mm superzoom does leave a lot to be desired. The second advantage that the prime lens has is that it has a wider maximum aperture. A zoom will not have as wide an aperture, and as you go up to the telephoto end, the f-stop increases as well. The advantage of the zoom is that it saves you carrying around a lot of lenses and having to walk backward and forward, getting things in shot.

THE CLASSIC PORTRAIT LENS

The standard lens for portraiture is the 50mm prime lens. This, on a digital SLR, is effectively a 75mm lens, so it gets you quite close to the subject, and is therefore unusable when space is very tight. However, the quality is better than that of a zoom and, crucially, it is usually equipped with either an f/1.4 or f/1.8 widest aperture. This is fantastic for throwing the background out of focus. For that and the quality reason, you are recommended to own a 50mm prime lens for portraits.

THE TELEPHOTO APPROACH

There are some—Lord Snowdon in the UK for one—who advocate shooting portraits with nothing less than a 200mm lens. The reason is that the field of view is quite narrow, so it isolates the subject, and telephoto lenses have less depth of field at the same f-stop than a wide-angle lens, so it's easier to get the background out of focus. It also tends to flatten the face, reducing things like large noses! The downside is that you need lots of room to use it. In digital terms, you are looking at around 135mm, which would effectively become a 200mm lens.

GO MAD, USE A WIDE-ANGLE

There are three approaches to using a wide-angle lens in portraits. The first is that it enables you to get the surroundings into view, and as long as the subject doesn't stand too close to the camera, distortion is kept to a minimum. The second approach is to make them stand very close, shoot at around 28mm effective, and use the distortion to creative effect. If the camera is near the head, then the head becomes larger and they appear to lean into the camera. If the camera is near legs or feet, the feet become bigger or the legs become much longer. The third approach is to use a very wide angle—something like a 12mm lens that gives an 18mm field of view on a digital. This, when used closeup, creates massive distortion and should only really be employed when outlandish effects are required.

28–300mm superzoom

50mm prime lens

18–50mm wide-angle

IMAGE EDITING: BEST VERSUS BUDGET

Usually in life you get what you pay for, meaning that if you buy a professional image editing package, you get untold power compared to the packages on offer to the home user on a budget. Except that this isn't the case any more. If you want to spend the money, and you need certain professional capabilities from your software, such as using CMYK output or creating vector-based frameworks into which images are added, then it's justifiable. The good news for the average digital photographer is that much cheaper software has nearly as much to offer.

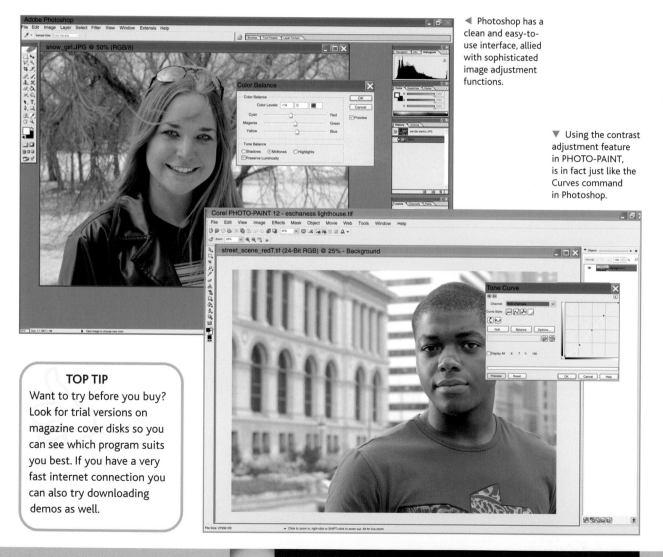

◀ Photoshop has a clean and easy-to-use interface, allied with sophisticated image adjustment functions.

▼ Using the contrast adjustment feature in PHOTO-PAINT, is in fact just like the Curves command in Photoshop.

TOP TIP
Want to try before you buy? Look for trial versions on magazine cover disks so you can see which program suits you best. If you have a very fast internet connection you can also try downloading demos as well.

BRIGHT IDEA
Moving over from film and miss your favorite stock? Look for a Photoshop-compatible plug-in that emulates different film stocks.

THE PROFESSIONAL CHOICES

In one corner there is the Adobe Creative Suite, starring Photoshop, Illustrator, and some Web-specific software, and in the other there is CorelDRAW Graphic Suite, featuring CorelDRAW, PHOTO-PAINT, and some vector animation software. You could pitch CorelDRAW against Illustrator and PHOTO-PAINT against Photoshop. The results would be a win for CorelDRAW and a knockout for Photoshop.

If you are primarily involved in creating graphics based around vector drawing, which involve some digital photos, then the Corel package is the better choice. If you are creating graphics, particularly composites, with a view to commercial reproduction, then Photoshop is the winner, both against professional and home-user software. For the digital photographer with money to burn, Photoshop is a class act with new healing and blemish removal tools, but particularly it allows for complex adjustments to be made to images that need a lot of work. PHOTO-PAINT, on the other hand, is a neat photo editor with some good filters and adjustment options, but is object- rather than layer-based.

PLUG-IN FILTERS

Both Photoshop and PSP use a compatible form of plug-in filters that extend the capabilities of the program. Third-party manufacturers supply a wide variety of filters that can do everything from turning photos into infrared, to creating pieces of artwork.

HOME USER

It's here, really, that fantastic value for money can be found. As digital photography has taken off, so people have turned to their computers to enhance and correct their images. The two main choices here are Adobe Photoshop Elements and Corel Paint Shop Pro. Elements contains a lot of the features of its parent program, Photoshop, it is cut down and doesn't have some of the masking and adjustment options and lacks CMYK support. With the latest release of PSP, even more digital photography-specific features have been added, including black and white film emulation, advanced sharpening options, and, best of all, a set of makeover tools for removing blemishes, yellow teeth, and uneven suntan. The only count against PSP is that it does require a fast computer to run it well. If you have an older computer, then Elements is probably a better bet; otherwise PSP is arguably the winner here, with considerably more features and (vital for commercial print) CMYK support.

▼ One of the highlights of the new version of Paint Shop Pro are the Makeover tools, with which you can easily fix blemishes. It also now supports color profiling.

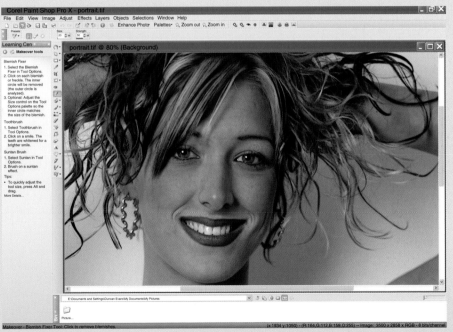

THE RECOMMENDATIONS
COREL PAINT SHOP PRO X
ADOBE CREATIVE SUITE 2
ADOBE PHOTOSHOP ELEMENTS 3
CORELDRAW 12 GRAPHIC SUITE

2 WORKING WITH YOUR SUBJECT

The starting point for any portrait session is finding subjects willing to pose for you. Getting the most out of the subject is then your task as a photographer, whether it's simply to get them to relax or to adopt a particular expression or mood. You also have to know how to pose subjects, learn the basic rules of composition, and be able to construct a visual narrative from your photographs. Consider these the basics that you need to master before moving on.

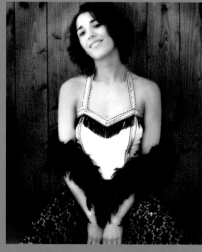

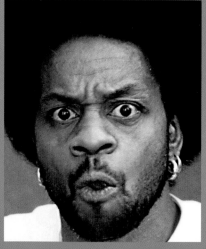

▲ The Eighties make a comeback in these glamorous shots that have tongue firmly in cheek—while a setting sun makes for a warm and flattering light.

▲ Contemporary shots can be informed by other eras. Here's a chiaroscuro effect— contrasting light with deep shadows using an ultrafast ISO. Photo: John Peristiany.

▲ Full-face portraits can be unforgiving, but also funny, provocative, or bold. Here a musician is shot mid-performance, to powerful and amusing effect. Photo: Howard Dion.

▶ Sometimes a portrait is worth a thousand words, evoking time and a place like no other medium. Photo: Paul Rains.

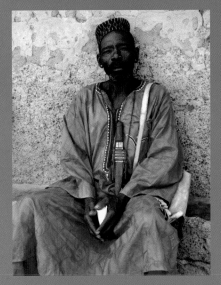

▲ (Right) Informal shots capture the subject in the moment more than posed shots are able to. Photo: Andrew Maidanik.

▲ Zooms combined with unusual, off-center compositions can create a fascinating dialogue between the subject, the frame, and the camera. This intimate shot speaks volumes about the subject. Photo: Howard Dion.

POSED SHOTS

Whenever you point a camera at someone, they will pose. It doesn't matter if the pose is one of carefree abandon or total indifference—it is still a pose. The only time it isn't is when you catch the subject offguard, or they are completely unaware of the camera, in which case it's a candid shot. How you pose the subject, though, is another question entirely, the answer to which depends on a bewildering number of facts. Who is directing the shoot, who is paying, what is the intention, how good is the photographer, how experienced is the subject, how good are they at taking direction, how is it being lit, what accessories have you got, and so on and so on. Posing the subject, even if you are working with someone who has a good idea of the pose they want, is a tricky business.

LEARN THE RULES, BREAK THE RULES

Before you can break rules, you need to know what they are, and the basic ground rules of portraits concern looking into the image. This means that if the subject is on the right of the picture, either their body or their face should be facing left. Conversely, if on the left, they should face right. It's to lead the viewer into the rest of the image and fill it out. If the subject stands on the right and faces right, the left side is abandoned and the image looks lopsided—unless there is something on the left side, in which case you've got two points of interest and the picture is then balanced.

The next key point is that the subject shouldn't stand in the middle, looking dead ahead. This looks flat and staid. You can bend this rule by having them angle their body to one side and look at the camera, or present the torso flat to the camera and angle the head to one side. You can break this rule when the lighting is dynamic, the pose outrageous, the clothing fantastic, and the background interesting—or if the subject is a celebrity. When the subject is a celebrity, the attention is on who the picture is of, not on how well it was shot.

SETTING IT UP

This setup is that of the model posing against a sandstone pillar while being illuminated by the golden light of late evening sunshine. Get the model to go through a routine of poses, moving arm positions, while you stand 10 feet (3m) back and use a short telephoto lens (28–70mm) or a 50mm (75mm effective on a digital SLR) lens. Set the camera on f/5.6 in

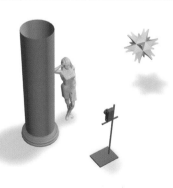

Aperture Priority mode and use center-weighted metering on the stonework. This will firstly create enough depth of field to leave the subject in sharp focus, while the background will start to blur, and the exposure time will ensure that highlights are not lost in the white fabric.

BRIGHT IDEA

If you get the pose right, but the picture still doesn't stand out, it may be the lighting. If you are in the studio try moving the lights, or using fewer, to create areas of shadow. If outside, keep the pose but reposition the subject relative to the direction of the light.

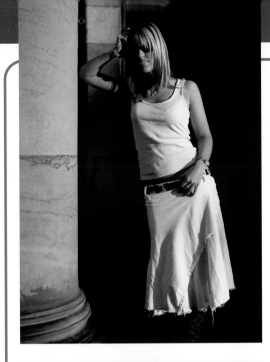

◀ The interesting thing about this image is that it appears to skate on thin ice because the model is flat on to the camera, and the pillar provides little depth. However, although the model is facing the camera, she is leaning over to the pillar, forming a slant across the image. The arms balance each other and the lower one is busy with the belt. The building, window, and shadow in the background provide the depth, her gaze provides contact with the viewer, and crucially, the light is from the side. This is where the dynamic element comes from, causing deep shadows at ground level, revealing folds in the clothes and adding shadow to one side.

TOP TIP

Digital Camera Automatic White Balance will attempt to correct the golden color of the light. Either use a manual WB setting on the camera or, if you forget, use Hue/Saturation in Photoshop and increase the saturation of the Yellow element by 15%. Also use Curves to increase the contrast.

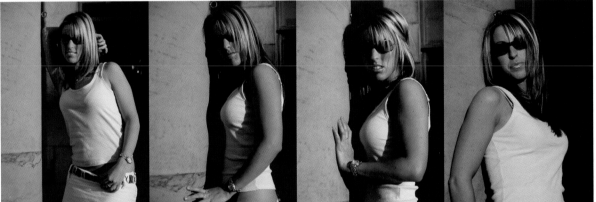

01 While the left arm is working well here and the hand is usefully occupied, this picture doesn't work because the other arm looks uncomfortable with the fingers appearing from the back of the head. The worst part, though, is that the figure is almost central and forms an awkward curve at the side of the pillar.

02 This is more intimate because we are closer, and it works much better. The visible arm naturally bends across the waist/ribs and the hand is lightly touching the stonework. The light is bright and orange, catching the subject's hair, and the body is facing into the image.

03 This, on the other hand, doesn't work. The arm is now far too angular, forming a U-shape. The mouth is slightly open, which makes the image look "forced."

04 Now the model is placed against the pillar and, though almost central, her body starts nearer the left side and leads you across the image. The head is turned toward the camera, making contact with the viewer. The structure is simple, with yellow to the left, white vest in the middle, and dark shadow to the right.

 TOOLS AT A GLANCE
- IMAGE > ADJUSTMENTS > HUE/SATURATION
- IMAGE > ADJUSTMENTS > CURVES

CATCHING THEM OFFGUARD

When you are working with someone, creating a photograph, no matter what the pose, they are always keyed up, knowing they are being photographed. This can lead to the subject looking tense. Now a good photographer can always make the subject relax, but even if shooting nonchalant-style poses, the subject will always have their game-face on. Catching them offguard is similar to candid photography where the subject doesn't know they are being photographed. The offguard shot is your chance to capture a thoughtful, wistful, or bored look that isn't being posed.

DON'T LOOK NOW
The subject won't be looking at the camera for this kind of shot and you can't pose them, either, so you need to compose it using the body shape available within the surroundings. Create the composition with the camera, positioning the subject appropriately within the frame, but do it surreptitiously, almost as though you are testing a camera setting. As such, you'll need to be a reasonable distance away to get the shot off without them noticing, so a 100mm lens or longer, even in the studio, will be required.

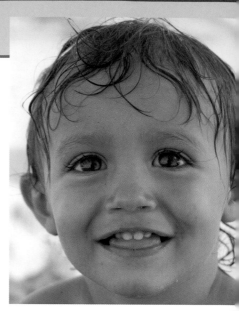

02 The beach vacations of our childhoods are captured in this simple, full-face shot of a youngster, sand in hair, who has just finished playing in the sea. The square, medium-format image shows the effect you can achieve if you move on from the traditional SLR.

01 There was a terrible flood in New Hope, PA, when the Delaware overflowed its banks and caused a lot of damage to this small tourist town full of clothing stores, restaurants, and art galleries. This woman was outside wringing out jeans that had been stored in the basement. Howard Dion watched her and noticed that every once in a while she would drift off to some other place or time.

BRIGHT IDEA
You can't get an offguard shot with someone seated under studio lights, so you need to use available light. Set your camera aperture to the widest possible, on AP mode, and shoot them wherever they are, in whatever light is available.

03 This guy was waiting for someone in the pouring rain when he was captured by Andrew Maidanik. The downcast pose matched the weather.

04 This shot of three friends was taken as they were about to start a ride on a rollercoaster. They were distracted by another friend, allowing Chris Middleton to grab this unposed "triptych" portrait of the excitement before the ride.

05 Here the model was sitting on a stone wall waiting for me to set up another series of shots. She was looking down a tree-lined pathway at a couple walking hand in hand. This was shot with a 50mm lens (75mm effect, don't forget) from fairly close. I could only get away with it because she had turned and was looking away.

EMOTIONAL RANGE

Asking your subject to run the gamut of emotional expressions is not as easy as it may sound. You'll find everyone can grin on demand, but after that it comes down to their natural acting ability. Some people are very good at expressing a wide range of emotions, while others, unfortunately, are not. It helps if the expression and emotion come as part of a scene or as a reaction. If you have to generate them, then you'll need to work with the subject, especially if they are self-conscious or camera-shy.

TOP TIP

If your camera autofocus isn't very fast, turn it off and set your aperture and lights to f/16 and then get the subject to leap up and down waving their arms around, pulling expressions like rabbits out of a hat. Fire away madly and get into the spirit. Digital capture is free, so don't be afraid to fire off a large sequence of shots to get a real cracker.

COMPOSE THE SUBJECT

If you want to capture emotion, you are normally talking about a head-and-shoulders shot so that you are up close and personal. Stand about 6–10 feet (2–3m) away from the subject and use a short telephoto lens to zoom in. For the thoughtful images shown on these pages, set a single light to the right and use a dark background.

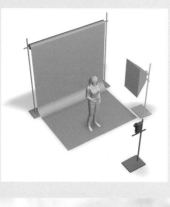

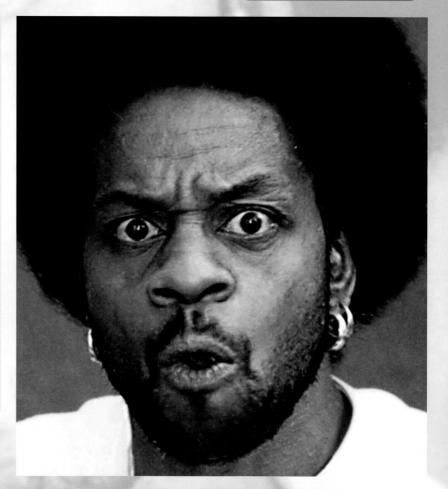

01 Howard Dion shot this image of a drummer in the street. One minute he was hammering away, and the next he looked up to see what the crowd was doing.

BRIGHT IDEA
Shoot someone looking thoughtful or sad with lots of shadow detail as it adds to the atmosphere. Conversely, make sure happy shots have plenty of light or color.

PUT THEM AT EASE

If you snap someone with a great expression on their face, then snap it and move on. If you need to work one up, then start by asking the subject to go through a routine of expressions, moving on to the next one after you press the fire button. By not giving them time to ponder on the pose, they will find it easier to get into it. For sad or thoughtful looks it can help if they look down or away from the camera, for two reasons. One is that looking at the camera while trying to be sad will probably make them laugh, and the second is that by looking down or away the pose becomes sad and thoughtful anyway, making a more convincing picture.

05 This is the shot the lighting diagram opposite relates to. By getting the model to look down and away, and putting lots of shadows into the picture, the mood becomes sad or thoughtful. Use Curves to make it more contrasty, or Levels for more shadows.

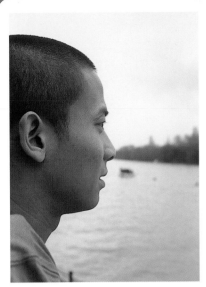

02 This wistful shot finds a boy lost in thought, and unaware of the camera. Photo: Suzi O'Keefe.

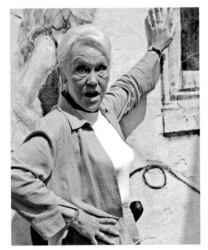

03 Catching people unawares, or in the act of copying someone else's pose, can lead to expressions of surprise mixed with indignation that they are being photographed.

04 This is a pure surprise reaction shot when someone distracted the model at the end of a shoot.

TOOLS AT A GLANCE
- IMAGE > ADJUSTMENTS > CURVES
- IMAGE > ADJUSTMENTS > LEVELS

IMAGE SEQUENCES: CHILD AND DOG

Children make excellent subjects but if they are not used to being in front of the camera, they can be shy and awkward. Your assignment comes from a friend who wants you to photograph her daughter. The daughter isn't that comfortable in front of the camera, so you need to give her something to do. A typical ploy is to give a favorite toy to the child, but in this case her favorite thing is a Dalmation called Pebbles.

INTERACTION

Get the child to hug the dog, show affection, smile, and play around with it. The more they relax, the less stiff the poses will be. Make time to shoot lots of photos, until the dog or the child gets bored. Look for unexpected interaction—the dog leaping up to lick the child's face or chewing sticks—and snap away.

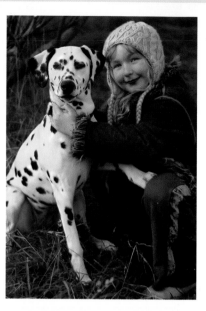

01 The girl is hugging the dog but the dog itself hasn't got into the spirit of the event yet. Just keep shooting until both are comfortable with what is going on. We ditched the hat after this shot as her hair was more interesting.

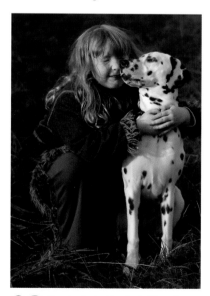

02 The dog is starting to feel happier about all the attention it is getting and turns to lick the girl.

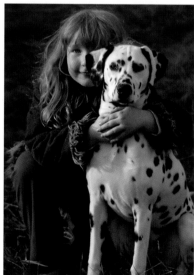

03 Exploit any characteristics of the dog breed. This is a proud dog who, when behaving, will stand to attention. The girl has started to show her impish character by half hiding her face behind the dog's head.

BRIGHT IDEA
If the dog isn't behaving, give it a bone or something to chew on so that it has the chance to settle down.

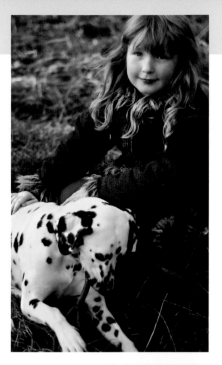

> ### TOP TIP
> Black and white dogs, like a dalmation, are extremes of tonal range and it is very easy to lose the detail in the white parts when shooting digitally. This also applies to any dog or fluffy toy that has white fur. Use -0.5 EV, or -1 EV if it is sunny, exposure compensation to ensure you get the detail.

◀ We have also produced a mono version using the Gradient Map and a black-white gradient. Monochrome pictures are very popular in lifestyle images, though usually tend to be almost high key in approach. With a dark coat and a black and white dog, this was always going to be a picture with significant contrast.

EDITING THE PICTURES

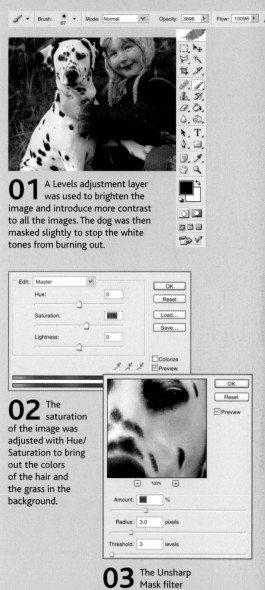

01 A Levels adjustment layer was used to brighten the image and introduce more contrast to all the images. The dog was then masked slightly to stop the white tones from burning out.

02 The saturation of the image was adjusted with Hue/Saturation to bring out the colors of the hair and the grass in the background.

03 The Unsharp Mask filter was used on 50% setting to increase the sharpness and bring out the texture on the dog.

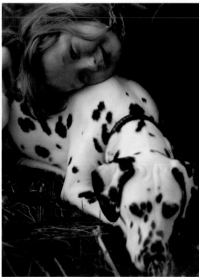

04 The dog is now busy chewing a stick, having settled down. This means the girl can now give it a big cuddle—it is her favorite after all.

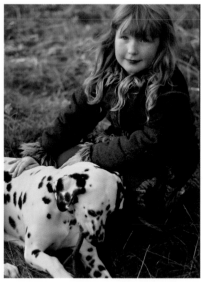

05 This is the pick of our photos, less because of the dog, more because the child is now relaxed and smiling naturally for the camera.

TOOLS AT A GLANCE
- LEVELS ADJUSTMENT LAYER
- IMAGE > ADJUSTMENTS > HUE/SATURATION
- FILTER > SHARPEN > UNSHARP MASK
- IMAGE > ADJUSTMENTS > GRADIENT MAP

FINDING YOUR SUBJECT

To the uninitiated, finding subjects for portraits is unfathomably difficult. It's the domain of professional, high-flying photographers, with the funds and skills to hire the best an agency can offer. Except that it isn't. There are subjects all around. You can start with friends and family, you can photograph people when you go on vacation, and you might even find aspiring models who will work with you to build up their own portfolio of shots.

THE EYES HAVE IT

The eyes are the windows to the soul, so the saying goes. Of more relevance is that eyes help set a face off, and if you have a specific project in mind, then finding someone with the right look starts with the face and eyes. The eyes of old people can suggest age and wisdom, perhaps sorrow, or a cantankerous spirit. Those of the young can suggest innocence, rebellion, or excitement. It doesn't matter if the actual subject is none of these things, it's what the eyes and the photograph suggest that matters. So, making eye contact with the camera is one of the strongest connections to the viewer that the photograph can make, while avoiding eye contact shifts the entire narrative of the photo and your portrait will tell the story of that evasion.

USE THE INTERNET

There are some very good, multinational Web sites that specialize in providing contacts for photographers and models, allowing both to post messages regarding a variety of different shoots. By posting your shoot details and location, you can then sit back and wait for interested parties to come to you.

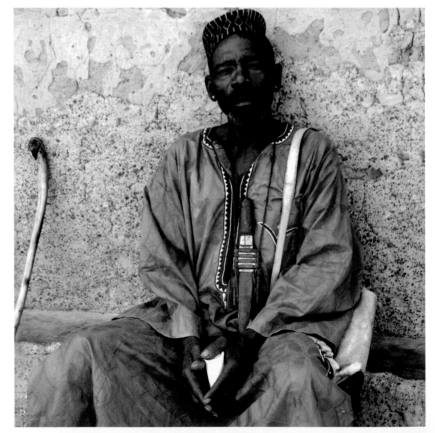

▶ When on vacation in destinations and cultures a long way removed from your own, you may find plentiful portrait subjects—but ask permission first. Photo: Paul Rains.

BRIGHT IDEA

Just starting out, no cash for models? Place an advert on a Web site and offer a CD of digital images, or prints, instead of money. This is known as Time for CD, or Time for Prints (TFCD or TFP). There are always models coming onto the scene who need pictures for their portfolios. This way you get to shoot and practice, and they get pictures to show what they are like.

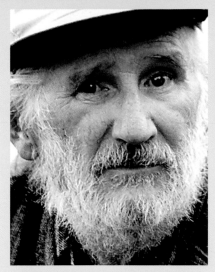

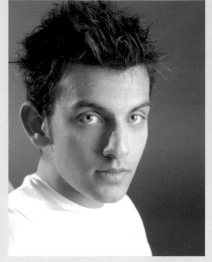

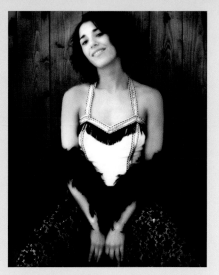

▲ If you have elderly relatives in the family, they can make terrific subjects—especially in black and white, which is particularly adept at capturing the lines and texture of older skin and the aged beauty of gray or white hair. Photo: Howard Dion.

▲ Unusually, the Asian man in this portrait has pale blue eyes, which establish an instant rapport with the viewer. Finding a model whose eyes communicate emotions strongly is an advantage in portrait photography, which should tell us something about the subject as well as capture their appearance. Photo: model's own.

▲ Try to find aspiring models who will give you "time for prints" (their time for copies of your prints). The more unusual or distinctive your project idea, the more interest there will be in it, and you both get images for your portfolios. Photo: John Peristiany.

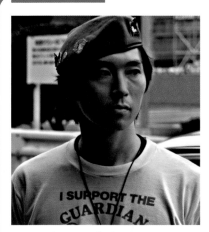

▲ These days you will often find community security personnel patrolling cities. Try to catch people at work rather than posing for the camera—but beware, of course, of being seen as a security risk yourself!

▲ Use Variations with dashes of red and yellow to add a quick and easy sepia-like tone to your image.

TOP TIP

If you intend to use any photos, except candid shots, commercially, then you will need a model-release, or copyright-release, form. This details the shoot and assigns all the copyright to you, the photographer. It needs to have the model's name and address and be signed by them.

TOOLS AT A GLANCE
- IMAGE > ADJUSTMENTS > VARIATIONS

INSPIRATIONAL CANDID IMAGES

Candid images can make for charming portraits where the subjects are unaware that they are the focus of your questing lens. Similarly, candid-style images are set up to an extent, but with a view to letting things happen while the shutter is firing. Get out on your own, with friends, to parties, or away on an outing and take along your camera to see if you can grab images of people as they appear in unguarded moments.

◀ This candid shot of musician Nick Zinner works because the guitarist is lost in concentration: a characterful image of someone doing what he loves always makes for a strong photograph, and a true portrait.
Photo: Sophie Martin.

▲ Here the subject is isolated at the center of a red wall and bedspread, creating both a painterly composition and a study of character. This type of portrait implies a story that intrigues the viewer. Photo: Martha Evatt.

TOP TIP
If you are shooting from a distance using a compact camera, try setting the aperture to f/2.8 to knock back the background. Compact cameras have more depth of field at wider f-stops than SLRs.

BRIGHT IDEA
If you are setting up a candid-style shot outside and have someone to assist, then get a large reflector, or a big piece of white cardboard, and get your assistant to stand just out of shot, facing into the sun. The card will reflect light back into the deep shadows on the face.

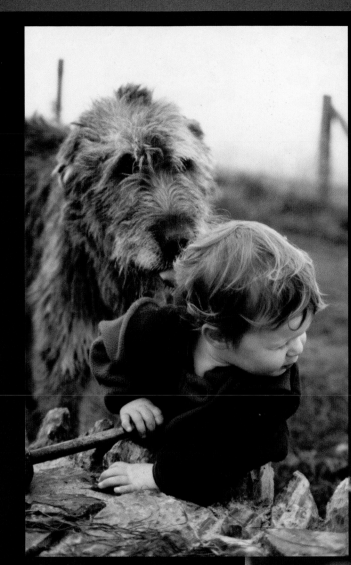

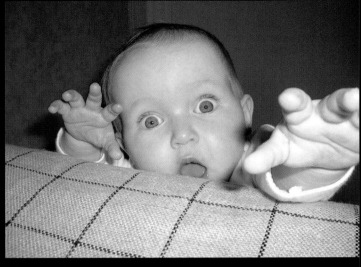

▲ Babies often make for a different type of candid shot, in that they are unaware of the camera's purpose and they haven't learned to be camera shy. Photo: Iain Gibbons.

▲ (Above) This rural scene works because of several elements: the huge dog and small child, the soft-focus effect, the angled composition, and the "story" of the bond between child and pet. Photo: Lizzie Patterson.

▶ (Right) Although this image might at first appear set up, it is a genuinely candid shot of two people embracing at the end of a dinner party. Photo: Lizzie Patterson.

3 PORTRAIT TYPES

How you shoot someone, with regard to the length of the shot, affects everything from lighting, to posing, props, and background scenery. By learning the strengths and weaknesses of each category of length and type—formal and informal—you can determine what will best suit your subject and the circumstances under which you are photographing them.

▲ Classic black and white adds dynamism to straightforward portraits, turning them from mere face-shots into studies of line, texture, shade, and form.

▲ With skill, even the simplest, posed studio shots can reveal character and depth in the subject, particularly in their eyes and facial expressions. Photo: model's own.

▲ Family shots and group compositions work when the subjects are comfortable with each other, and the environment is more relaxed than it is for some solo portraits.

▼ Don't be afraid to play with unusual angles to capture stunning images that add drama to your subjects.

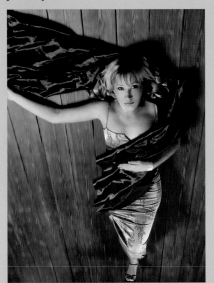

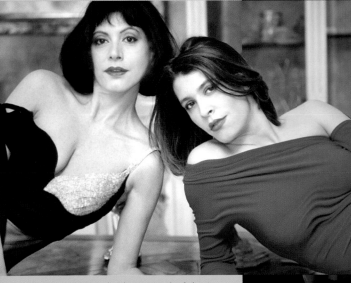

▲ Create images that have a touch of classic glamor to them, making the shoot into an occasion rather than a chore for camera-shy friends. Photo: John Peristiany.

▲ Mix color in the environment and your subject's attire to put together eye-catching images like this. Photo: Simon Pole.

FULL FACE

Putting it another way, this is a head-and-shoulders shot, which is the standard closeup portrait shot. It might seem like the dullest way ever to shoot someone's portrait, but in fact there is an almost limitless number of ways it can be done, using angles, poses, crops, and lighting. David Bailey was the first photographer to really make a radical statement with the full-face shot, and everyone else has been following his lead ever since. The current trend for head-shots is not to include all of the face. Just get right in there as close as possible. However, we'll start with the basics and work up.

SETTING IT UP

A typical head-and-shoulders shot can be lit in numerous ways, but for a basic shot try this. Position the subject 5 feet (1.5m) in front of a white background. Have two lights on either side, but behind the subject, pointing at the background. Meter the output from the lights until you get a reading of f/16. Then set a flash head with a softbox in front and to the left, so that it is alongside you. You should stand another 6–10 feet (2–3m) away from the subject, shooting using a 50mm prime lens or short zoom equivalent. Set the main flash power to meter on the subject at f/8. You will now be able to shoot the subject with some shadow detail on their body, but the background, because of the brighter rear lights, will be completely white.

▲ This catalog-style shot is simple and effective, because the subject is at ease and having fun with the shoot. Sometimes simple is best, and her brightly colored top adds to the informal, fun atmosphere.

▲ And who says you even have to look at the camera? For a more mysterious, melodramatic, or moody shot, have the subject look away and use dramatic lighting, positioned below the level of the subject.

BRIGHT IDEA
Rather than be restricted with a massive closeup shot, why not take one from further back and experiment with the Crop tool for numerous shapes and severe closeups.

EYE CONTACT

Making the most of the eyes is important in this kind of shot because you are so close to the subject. If they look right into the camera, then you get a direct connection with the viewer, and the closer the crop, the more powerful this is. Looking away sends another kind of signal, that the subject is deliberately avoiding the viewer's gaze. If subjects are made up for the shoot, the type and strength of eye makeup can completely change the look and feel of an image—make sure that it matches the mood of the shoot.

01 The strength of this off-center daylight shot with additional flash is in the eyes, hands, and facial expression. Here the photographer got the subject to "play" at being a model. Photo: Chris Middleton.

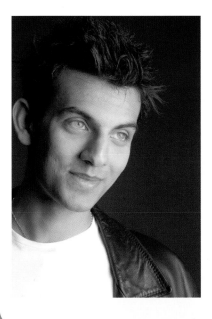

02 This more casual, "classic" shot finds a different character in the same model. A flash with "umbrella" reflector to the right of a 6x9 camera scatters the light on his face, while the dark backing absorbs it. The backdrop complements his jacket and hair. Photo: model's own.

03 This is the photo that the lighting guide opposite refers to. To add an extra element of dynamism into a very standard picture, the camera has been tilted so that the subject angles across into the image.

TOP TIP
For soft flattering light on the subject, use a softbox fitted to the flash head. For sharply defined shadows and harsher light, take it off or use tungsten lamps.

39

FULL-FACE ASSIGNMENT: ACTOR'S PUBLICITY SHOTS

Your task is to take someone and give them a classic black and white head-and-shoulders shot for an acting portfolio. This means that it should be moody, yet show lots of character and that the person should come through, rather than the outfit they are wearing. You want to show the stripped-down person who can be applied to a role, rather than someone already in a role.

SETTING IT UP

Two background lights at f/8 to keep the background white and one foreground flash unit with a softbox, set to the right at 45 degrees from the camera or further. This main light should be set on a low power to get an aperture rating of around f/4. Use a 50mm prime lens or a short telephoto lens and stand close enough to just include the head and shoulders. Angle the torso slightly and tilt the head a little so that it isn't all flat. The subject needs to look right at the camera.

01 Here's one effort. There's too much shadow and no highlight detail on the left side of the face. The pose is too flat as well.

02 The next shot is better, but it's still too much sideways on for the light. A reflector was used on the other side of the face to lighten it up, but the overall effect is just one of murkiness.

03 However, this is the shot we want. This is the color version, showing a much better spread of light across the face. This could be converted to black and white as is, but, for more impact, we're going to crop it.

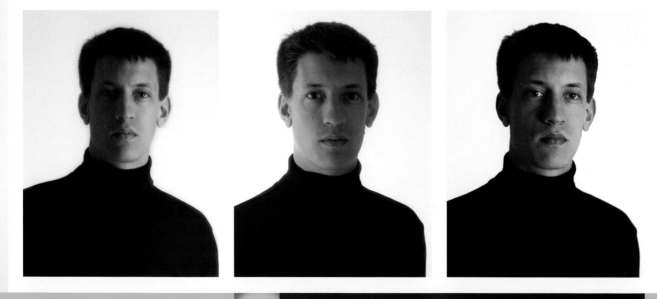

BRIGHT IDEA
Start off at head-and-shoulders range and then move in, making the composition tighter until you are cropping the top of the head. Get a range of shots, from pulled back to right in close.

CONVERTING TO BLACK AND WHITE

The best way of doing this with digital files is to use the Channel Mixer and tick the Monochrome box. That way you can specify how much of each red, green, and blue channel goes into making the mono image.

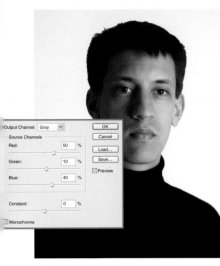

01 The first task was to convert the image to mono. Settings of Red: 50%, Green: 10%, and Blue: 40% ensured a good, dynamic range of tones.

02 To give the picture more impact, Curves was used with an S-shape to deepen the shadows and brighten the highlights.

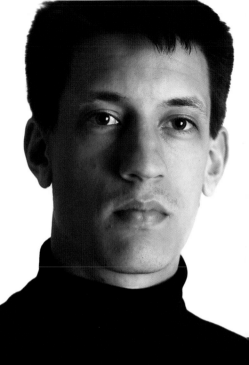

▲ With a tight crop, strong shadows, and sharpened detail, here's one for our budding actor to drop on an agency desk.

03 For male faces it's good to see surface texture and for the picture to be as sharp as possible. Unsharp Mask with a strength of 75% was used to bring out all the detail. This also gives a picture more contrast.

04 It's worth saving the image here as this one is worth keeping. However, to get in really close, in a David Bailey style, the Crop tool was used to cut across the top of the head and remove the dark jumper at the bottom. The point about doing this is that it concentrates the view on the eyes and facial features.

TOOLS AT A GLANCE
- IMAGE > ADJUSTMENTS > CHANNEL MIXER
- IMAGE > ADJUSTMENTS > CURVES
- FILTER > SHARPEN > UNSHARP MASK
- IMAGE > CROP

SEEN IN PROFILE

The profile, or side-on shot, reveals strength of chin, straightness of nose, slope of forehead, and shape of face. Many people, who look fine straight on, look less good when viewed from the side. However, for all subjects, there are ways and means of shooting a profile shot so that any weaknesses are hidden and the positives are highlighted. The other consideration is that you don't want the flat, side-on picture to look like a police mugshot.

SETTING IT UP

To setup a profile shot, get busy with the lights to start with. The model should stand 6 feet (2m) in front of the background so that you have plenty of room to work with. The main key light is to the right of center, at head height, fitted with a softbox. The power should be set to f/11. To the left, set a secondary flash with a softbox, using a lower power setting of f/8. This is to provide light on the far side of the face. From above there should be a small light, designed to light the hair. This should have a narrow focused beam, but be softened. The power should be f/8 so that the highlights on the top of the hair are nearly as bright as those on the back of the hair. The camera should be straight on.

PROFILE VERSUS PROFILE

It's amazing how people with a similar build and style can actually vary once you turn them sideways on. Here are two profile shots of models the same height, with long hair. Compare the two. The model in green has an almost vertical forehead, and a fine nose. The other model has a more sloping forehead and a Romanesque nose. However, she has a much stronger chin than the girl in green.

BRIGHT IDEA
If the subject has a weak chin, aim to turn the head toward the camera a little, and raise the camera up so that you are shooting downward. This will conceal it.

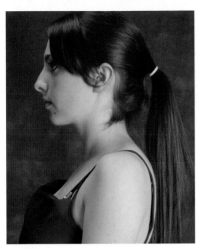

01 The first profile here is flat on to the camera, and even with a reasonably interesting lighting arrangement, the picture is staid.

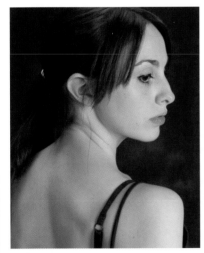

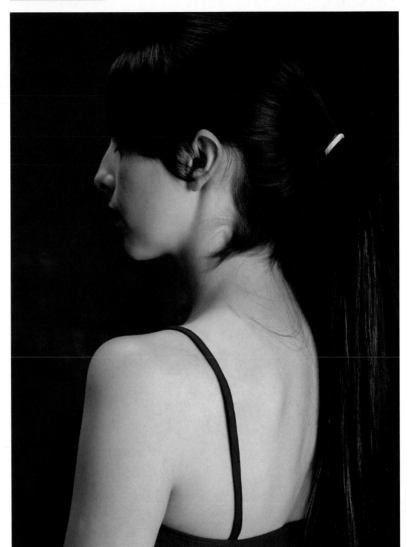

02 For this shot the model has turned her back to the secondary light and her face toward the main light. The face is still in profile, but the shape is more interesting and the body shape is more dynamic. Watch out for creases in the neck and, on a practical level, bra straps with this kind of dress.

03 This is a development of the first shot. The head is going in almost the same direction and angle as before, though tilted slightly down while the body assumes a dynamic shape in the light. Severe neck creases are avoided, and the main light highlights her long hair, which is one reason to take a profile shot in the first place. For this shot, we also Cloned out the bra strap.

TOP TIP
Use Curves in Photoshop to darken the shadows and bring out the highlights. Use the Clone Stamp tool in Lighten blend mode at 100% Opacity to carefully remove stray hairs.

TOOLS AT A GLANCE
- IMAGE > ADJUSTMENT > CURVES
- CLONE STAMP

ANGLED ASSIGNMENT: STYLISH BLACK AND WHITE

Here we're going to produce a stylish, angled companion image to the actor portrait, this time for an actress's portfolio shot, which she can send to prospective agents and casting directors. Our subject wants to look strong and feminine at the same time, but not to exude so strong a character that it restricts her potential roles.

SETTING IT UP

Photographer Lizzie Patterson explains that the lighting setup for this is straightforward and simple, and aims to create a very natural-looking light that flatters the features and avoids the artifice of a studio shot. She set up a softbox—you can use an equivalent source of warm, diffused light—to the right of the camera. A reflector bounces the light back onto the model's right side. Lizzie has used a curtain as the backdrop—the strong, vertical lines complement the soft lines of the model's appearance and physique. She shot at ISO 100, $1/125$th sec, f/4.5 to knock the background slightly out of focus.

▲ This isn't a bad shot, but it's not right for the portfolio. The angle makes her appear slightly stocky, which she isn't. The chair is too much in evidence and the arrangement of her hands is fussy and too distracting.

▲ The soft curves of her face and hair are caught in this pose, but it seems a little too confrontational, which risks casting the actress in too specific a role. The strong verticals of the curtain are too prominent for comfort, as is the light on one side of her face.

▲ This is another good near miss: a superior composition to the previous shot, but her expression is rather blank. As a result, the portrait works as a formal composition, but falls down on capturing her personality.

BRIGHT IDEA
Never tell a model to "relax." Ask them to lean their weight onto one leg and you should find that they stand naturally and appear more at ease.

▲ We've kept her clothes simple and timeless to show off her feminine neckline and collarbones and to accentuate the sweep of her hair. This shot is an excellent full-face portrait that captures her natural beauty: a good companion to the angled shot.

▲ Here's the first of our two successful angled shots: an enigmatic portrait that suggests all manner of hidden depths and stories. Perfect for an actress seeking new roles!

◀ Here's our second angled portrait —a less enigmatic image that stresses the cheekbones. Although her makeup looks understated, lip and eye makeup was much stronger than it would have been for a color portrait. All photos: Lizzie Patterson.

TOP TIP
Use backgrounds that accentuate and flatter the subject—for example, strong vertical lines can complement a soft and feminine subject.

THREE-QUARTER LENGTH

In many respects, this is the easiest length of portrait to shoot. You have the added interest of seeing more of your subject and playing with angles and poses, but you don't have to worry about the feet or showing where they are standing. Because there is more of the person than just a head-and-shoulders shot, you can compose and interact with the background, yet it's closer than a full-length shot, giving it more immediate interest.

INSIDE OR OUT?

Some longer shots suit one place or the other more. In the case of the three-quarters length shot, it's good to go both inside and out. In the studio, you can shoot against light or dark backgrounds without worrying that the subject is floating, while outside the fact that this shot is so compelling allows you to use locations where another length of shot would look dull.

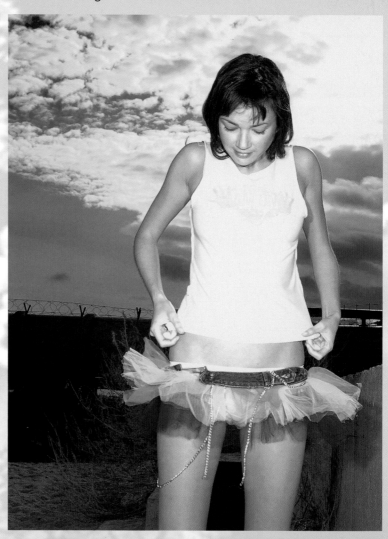

▼ Outdoor three-quarter-length portraits allow you to explore more fully the relationship between subject and location while still concentrating on the person in the frame. Photo: Jason Keith.

BRIGHT IDEA
If you shoot an image full-length and it doesn't really work, experiment with cropping it to three-quarters length to see whether it suddenly becomes effective.

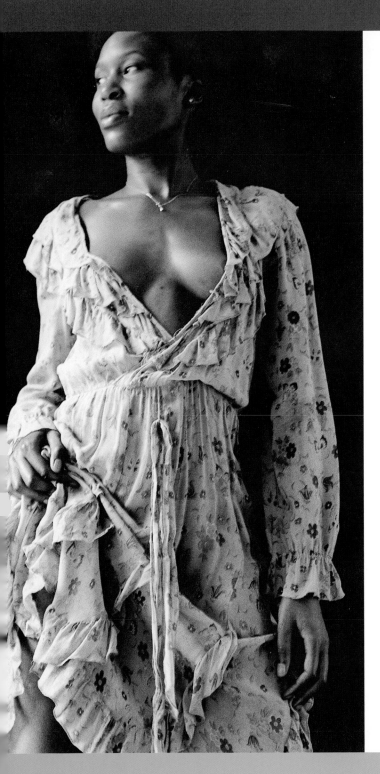

TOP TIP
Use the three-quarter length shot to create a dialog between subject and environment. Imagine the frame is a physical doorway and get your model to pose within it imaginatively.

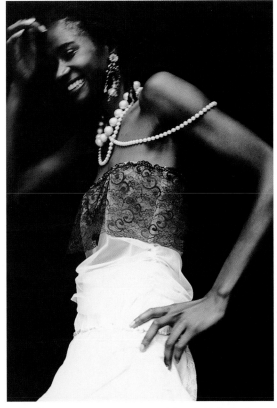

◀ (Left) Shot from below, this image is powerful and feminine—showing a woman who is confident and proud. Note how the light contrasts her figure against both clothing and backdrop. Photo: Lizzie Patterson.

▲ (Above) This "softer" approach shows a gentler femininity than the marked contrasts of the previous image. Shot from a slightly higher angle, it makes clever use of frame and a fast ISO. Photo: Lizzie Patterson.

47

THREE-QUARTER ASSIGNMENT: MODEL PORTFOLIO

You have been asked by an aspiring model to help him create some shots for his portfolio—he wants to get some work on a local youth magazine. This kind of assignment is ideal if you can find the right model: you both get some pictures for your portfolios, and you can both explore how a photoshoot works. Let's try for a three-quarter-length picture, exploring the personality of your subject.

SETTING IT UP

Use a 50mm or equivalent lens to get close up, without any distortion. Set the key light to the right, at 45 degrees. If you can, use an umbrella-style reflector to scatter the light on the subject's face, hair, and clothing, while providing a bright point of light in the eyes. Set the power to be around f/22. Set your camera to manual mode, f/22 aperture, $1/125$th sec to sync with the light and connect it up. Now, shoot a series of three-quarters pictures. (Use an optional second light for hair detail.)

SET THE MOOD

You want a strong personality to come across. However, if you are both beginners, there may be a tendency for the shots to look strained. Get him to bring along a range of favorite outfits, and go for different moods with colored backdrops. Find out what he is comfortable with, but most of all try to capture the personality behind the eyes.

▶ This first shot is an excellent start: the pose is interesting, although perhaps less good for the clothing. He looks confident in the camera—a useful face-shot, but it's less successful as a three-quarters shot. Perhaps keep this and crop it as a simple portrait (as above).

▲ This shot doesn't work so well, because he's adopting a personality that he isn't comfortable with. There's less of a meaningful connection with the viewer, and his expression is slack.

▲ This shot is a good composition —but that is because he is stooping, creating a curve on the left of the composition that complements the strong vertical on the right.

BRIGHT IDEA

New models often have no idea what to do with their hands. If they look awkward, try introducing a prop for a couple of shots, so that they have something to do and become less self-conscious.

▲ Here we've gone for a white backdrop and a change of clothes to try to capture a "lighter" look than the darker, moodier shots of before. He seems more comfortable with this, but the expression isn't right.

TOP TIP

If you are shooting a blonde model, some digital cameras will lose the highlights in the hair. In this case, it is better to deliberately underexpose the picture by one whole stop of light and then tweak the image later.

▶ Got it! Our model has expressive eyes and a fresh-faced look that suits this lighter, softer approach. This shot captures his personality perfectly and he looks relaxed. All photos: model's own.

FULL LENGTH

The full-length portrait shot is the hardest to get right, compared to head-shots and three-quarters-length ones. Not only must the subject's upper body be posed with regard to the lighting and the hands be kept busy, the model must also be standing naturally, or sitting at ease. There's a lot more that can go wrong, such as chopping the bottom of the feet off, and any nervousness in the sitter will be instantly transmitted into the photo.

SETTING IT UP

The setup for the studio shot, right, consists of the model standing against a seamless background about 5 feet away from the back. Place two flash heads with no diffusion to the left and right, at the back, pointing at the background. Meter the power and set the output so that you get a reading of f/11. Stand 10 feet in front of the subject, using a short telephoto lens so that you can fit them in the shot. At the front, on either side of the camera, there should be two main flash heads fitted with softboxes, for more flattering light. Meter from the model and adjust the flash heads so that the power reads at f/8. This means the background lights create extra areas of brightness on the background. Set the camera to the standard flash sync speed of $^1/125$ sec and set the aperture to f/8 in manual mode. We've then cut the model out of the background in this example.

◄ Getting your subject to engage in a physical activity is a good way of using a full-length portrait as a study of the body in motion.

POSING THE SUBJECT

As in the spread on posing (see pages 24–25), this is all about making the subject look comfortable or dynamic in a full-length pose, not awkward, ungainly, or listless. Angle the subject to one side or the other to get a more interesting shape and ensure that at least one hand is doing something, whether it's placed against a hip, tucked behind the back, or holding a prop. The subject can then make eye contact with the camera, creating that link with the viewer of the image. When on location there is the scenery to interact with and to use to frame the subject.

► OK, we might be cheating a little by seating the model, but it is a good way of relaxing your subject and getting some interesting compositions.

BRIGHT IDEA
If you are stuck for somewhere to take photos, why not ask the owner of a local restaurant if you can shoot there out of normal hours. You may have to negotiate a small fee or some pictures in return.

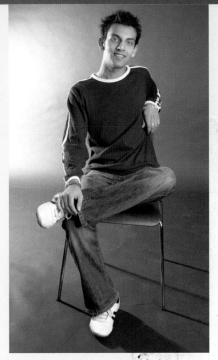

▼ Another strategy for taking eye-catching full-length shots is to shoot outside and make use of the natural textures and framing potential of walls, buildings, and grimy cityscapes.

▲ Here's a more formal pose made dramatic by the splash of light to the left of the frame, which creates a good framing device where it meets the fold in the backdrop.

◀ This is the one that works best: a simple, classic "catalog" style shot with a dash of color and panache.

TOP TIP
Imply character by contrasting clothing with background textures—scuffed denim with a rough brick wall, or a shiny backcloth with crumpled linen.

FULL-LENGTH ASSIGNMENT: SERIOUS, FORMAL POSE

Your task for the full-length assignment is to come up with an image that is graceful and yet a serious, formal pose. You have to shoot it against a plain background, so all the work is on the lighting and the pose. The end result should be black and white, so consider how well the outfit will convert to mono from a digital color original.

SETTING IT UP

While the assignment is down to you as to how you shoot it, here's how we went about it. The model is placed 6 feet (2m) in front of the background. The studio has a white wall with an infinity curve so there is no ugly join. Two smaller lights are behind the model, to the side, pointing at the background. They are set to f/16 power to blanket it in white. The camera is 10 feet (3m) in front of the model and the lens is an 18–50mm short telephoto, which gives an effective range of 27–75mm

on a digital SLR. Stand as far back as you can without bringing the key light into the shot—as mentioned, 10 feet is a good starting point. The key light is a large flash unit with a very large softbox, arranged on the left of the camera. This is set to f/11 power.

01 This is a good pose: one hand is active, the other relaxed. The body, though nearly straight on, is tilted slightly, as is the head. The right leg makes a bold lead across the picture.

02 This is another good pose because the arm bends and forms a nice shape over the hips and waist. The legs are pointing in different directions, giving movement throughout. The only real problem is that the model looks surly in this shot.

03 While the legs aren't doing a lot in this shot, at least they aren't clamped together. Both arms are busy, though the nearest one is perhaps too casual. The hand could have done with pulling up a little so that the arm didn't run straight down. The model is making good eye contact as well, by looking over her shoulder. Importantly, she is turned away enough to create a good pose, but not so far that her chest is on the other side of the picture, as this would make it look as if she was walking away.

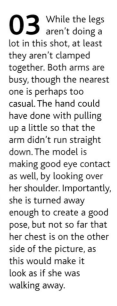

BRIGHT IDEA
If the model is too tense or a beginner, come over to her position and illustrate some of the positions to move into. An easy one to suggest is that she slowly starts walking toward you. This will free up her arms and make the legs move into natural positions—obviously you only have a limited time to get some shots off before she moves too far forward.

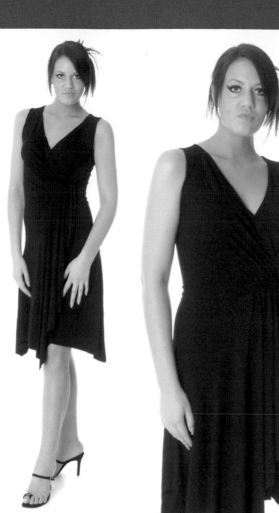

EDITING THE PICTURE

01 Having been shot in color, the image was converted to mono with the Channel Mixer.

02 Curves was used to whiten the highlights and specifically make the dress darker, toward black, instead of gray. It doesn't possess much fabric detail, so it is used for the shape and outline alone.

03 The Canvas Size option was used to add a 50-pixel black border around this white image. It served to hold in the detail.

04 Now we're trying some movement toward the camera, but this is easily the least successful shot. Both hands are in virtually the same place and the slight tilt to the body looks odd rather than dynamic. The legs are just getting in each other's way.

05 This is a subtle development of the last shot and works far better. The body is slightly angled now, which hides the fact that both arms are doing the same thing. On the left of the picture the arm forms a slight crook, so that it isn't dead straight, and with the legs swinging, they create a sense of movement.

TOP TIP

If you have the space, use a longer lens and zoom in a little, rather than stand close to the model with a wide-angle lens, because you need that field of view to fit her in. Wide-angle lenses at close quarters distort the image—creating thicker-looking legs or larger-seeming heads.

TOOLS AT A GLANCE
- IMAGE > ADJUSTMENTS > CHANNEL MIXER
- IMAGE > ADJUSTMENTS > CURVES
- IMAGE > CANVAS SIZE

PROPS AND HOW TO USE THEM

Props can be anything from something large and obvious, like a car, which dominates the picture, to the degree that the person becomes the prop, or something small like sunglasses, which gives the subject something to do with their hands. What you have to ensure is that the prop is sympathetic to the type of photo being taken.

SETTING IT UP

This is the setup for the column shot opposite. A wide-angle lens was used with the camera right in front of the subject to create maximum distortion. One key light was off to the right, set at f/16 power. The subject was asked to lean on the column for a more whimsical portrait.

▼ One of the easiest props to use is a pair of sunglasses. With these, the subject can be holding them, adjusting, or putting them on. When held they give something for the hands to do without drawing attention to themselves.

◄ With portraits of children, even contrived or setup ideas can be charming and effective. Here this "two shot" (to borrow a phrase from the movie industry) has real heart—even if the bear has not. The texture of the toy adds visual appeal.

TOP TIP

Make sure enough light falls on the prop, particularly if it's small. It's easy to overlook and, if done wrong, the prop will be virtually invisible.

BRIGHT IDEA

Use props that are typical of the sitter. Children, for example, love to play with toys and teddies, which can keep them under control as you shoot.

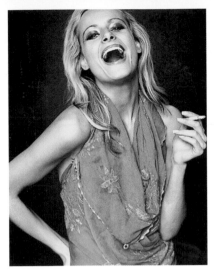

▲ Cigarettes may be frowned upon these days, but as in the classic Hollywood era, they somehow add a touch of noir glamor to black-and-white shots. Here our model is sending up the use of the prop in this charming and funny shot. Photo: Lizzie Patterson.

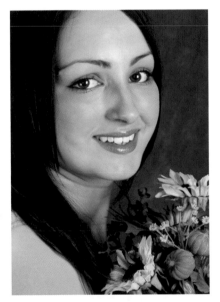

▲ A bunch of flowers makes an excellent and colorful prop. For them to work in this close-cropped shot, they had to be held right against the model, almost under her chin.

▶ The prop here is a Grecian column, on which the subject is leaning. To get a wacky, more offbeat portrait, a wide-angle lens was used right up against the subject to induce the maximum amount of distortion.

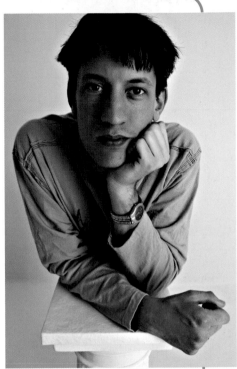

01 The original shot was rather underexposed, though this ensured that detail wasn't lost in the white column. Levels was used to spread the tones out.

02 The highlights were still too dark so Curves was used to brighten them, while keeping the midtones and shadows as they were.

03 The image was a little lopsided, so it was selected and then the Transform > Rotate option used to straighten it up.

TOOLS AT A GLANCE
- IMAGE > ADJUSTMENTS > LEVELS
- IMAGE > ADJUSTMENTS > CURVES
- SELECT ALL
- EDIT > TRANSFORM > ROTATE

PROPS ASSIGNMENT: "STAY COOL"

A local company wants some publicity shots in a "Rat Pack" mold—here we're using a fan prop just as singers from the era used a microphone (the theme here is "stay cool.") Imagine this is for a full-page advert, so leave room in the image for the wording. Choose a prop, and use your imagination!

SETTING IT UP

The key light is above and to the right of the camera. We've taken the softbox off to get a much harsher light, with deeper shadows. The power is set to f/22. On the left there's a secondary, smaller light, aimed at the face, providing fill light. This is set to f/16. The 50mm lens is used as this is effectively a three-quarters shot, and the camera is around 10 feet (3m) away from the subject.

TOP TIP

This type of image can easily be shot at home. Ensure you have a dark background, then set up a table lamp as the key light. You will need a tripod because the light level will be very low.

STYLING

The prop we've chosen is a classy-looking, silver metal fan. Cool is the theme, so clothing for the assignment is "Rat Pack" style—sharp suit and tie, with a 1950s edge. This is an advert, so don't overcook the styling; it shouldn't take attention away from the product.

01 The subject is smirking for the camera here. It's worth getting through a few shots, just to settle the model down so that you can get the right facial expression.

02 The trouble here is that there is not enough space for the advertisement wording. This is extremely important, and very easy to overlook when shooting. Visualize the image as a page.

03 There is enough room in the shot now, but the idea of having the fan on the right was that the light would reflect off it and filter through it. The actual result is that it casts a large shadow on the background.

04 Okay, we're virtually there now. There's plenty of space, the fan is on the opposite side of the picture and catches the light very nicely. Trouble is we've chopped the top of the head off the model, and that's wrong for the era of photography we're emulating.

BRIGHT IDEA

When you've completed the assignment, why not try some sepia toning, and then have a go at adding the wording that the advert might require.

01 Now we've got it. The pose is right, the product looks good, and there is space on the bottom left and right for wording. The image was then converted to monochrome and tweaked.

02 The first task was to brighten the image up a little by using a Levels adjustment layer. The background was then masked off so that it stayed dark.

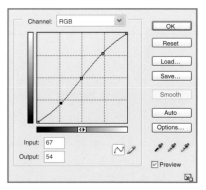

03 The image was then converted to monochrome using the Channel Mixer. With the Monochrome box ticked, values of Red: 35%, Green: 25%, and Blue: 40% were entered.

04 To really make the product stand out, a duplicate layer was created and the Unsharp Mask filter at 100% Amount was run. A layer mask was then added and the figure masked off.

05 Finally, a shallow S-curve using Curves was applied to darken the shadows and brighten the highlights a little.

TOOLS AT A GLANCE
- LEVELS ADJUSTMENT LAYER
- IMAGE > ADJUSTMENTS > CHANNEL MIXER
- FILTER > SHARPEN > UNSHARP MASK
- IMAGE > ADJUSTMENTS > CURVES

POSED—COLOR

The formal pose is the classic studio shot of elegance and quality on the one hand, or serious and thoughtful on the other. You can shoot any length for the formal pose, but it must be seen in a serious light. Formal poses are used for anything from families to corporate portraits to studied examples of evening wear.

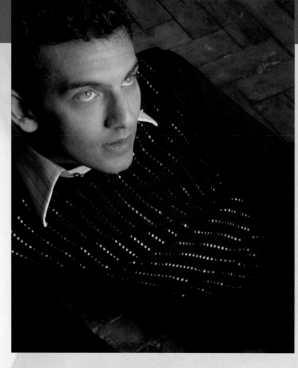

▶ Here the subject has been shot from above in a clever composition that is all about the angles in the frame, his face, his clothing, and the patterned floor. Look for details like this and use them in your work. Photo: model's own.

SETTING IT UP (FACING PAGE)

Have the subject sit in a refined pose, with arms making bent shapes around the waist. Set one light to the right, lighting the front, and a second to the left, lighting the side. Set both lights to f/16 power. As the left-side one is nearer, it will

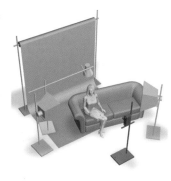

appear brighter, but the result will be highlights throughout. If available, aim a small hair light from above at f/8 power just to light it up a touch. Use a short telephoto lens (18–50mm) to frame the subject, and stand around 10 feet (3m) back.

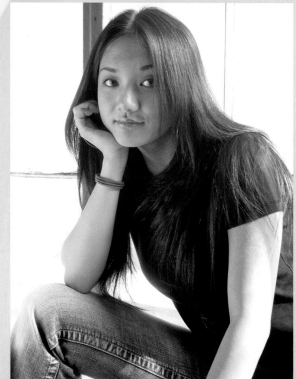

▶ This natural, less formal shot is still all about elegance, poise, and the model's sweeping hair.

BRIGHT IDEA

Lift your portraits out of the ordinary by looking for details that you can use to add an extra dimension, story, or visual theme to your work. For example, the angular portrait of the young man above is all about diagonals, which the photographer noticed and accentuated.

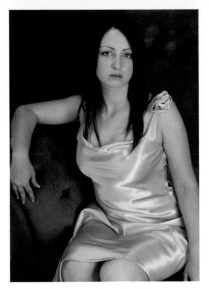

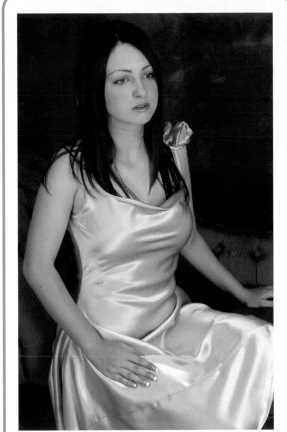

◄ This, though, is exactly the right picture, with very elegant arm and head posture. The back is against the upright part of the chaise longue so that the legs can extend forward and allow the dress to drape much more attractively. The combination of the lights casts highlights all over it, making it shimmer.

▲ This is how not to do a shot of someone sitting on a chair or chaise longue. She looks like a bag of potatoes, the knees are ungainly, and the arm on the left looks like a bird's wing.

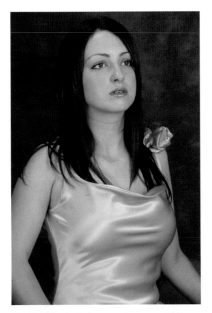

▲ This is better because we've moved the arms in to create subtle shapes, but the crop is too close and she's looking up into the air too much.

► Curves were used to boost the contrast by darkening the shadows and lightening the highlights.

TOP TIP
You want good depth of field throughout an image like this. Ensure that the lights are strong enough to shoot at f/16.

Channel: RGB

OK
Reset
Load...
Save...
Smooth
Auto
Options...

Input: 185
Output: 198

☑ Preview

TOOLS AT A GLANCE
- IMAGE > ADJUSTMENTS > CURVES

POSED—BLACK AND WHITE

Stylish black and white has gained in popularity as more people have come to appreciate its unique potential to throw a flattering emphasis on line, texture, composition, and tonality in posed portraits. Where black-and-white films had become hard for many people to purchase, digital has given people back the option, but with new degrees of sophistication thanks to the various software options for creating monochrome images: desaturation, Levels, and individual color channels in the Channel Mixer, for example.

FLATTER WITH MONOCHROME

Here is a range of inspirational portraits to show you just a few of the many options for the numerous types of posed portrait that you can achieve with black and white: chic and elegant; moody and graphic; and subtle and stunning. Use these images as starting points for play and experimentation. Explore the effect of desaturating images, change the Levels setting on a desaturated image, and explore your software's Film Grain, Noise, and Blur filters if you have them. For more extreme experiments, try viewing individual color channels.

TOP TIP

To understand how certain colors "map" to black and white, get your model to wear a range of different, single-colored tops. Then look at how each color behaves when you desaturate it. Keep a note for future shoots and avoid those murky grays!

▼ This companion shot takes the opposite approach by showing the model full face, and making this a study of whites and grays against the dark background. Two shots in which subject, theme, and medium are coherent and brilliantly realized. Photo: Lizzie Patterson.

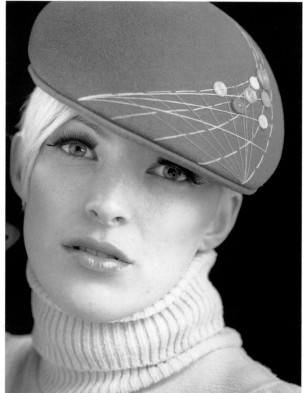

▶ This great shot creates a dialog between the pale skin and blonde hair of the model and the dark clothing and background. A little imagination and clever use of light and shade creates a stunning shot that implies the model's beauty rather than shows it off. A slight Gaussian blur and film grain completes the effect. Photo: Lizzie Patterson.

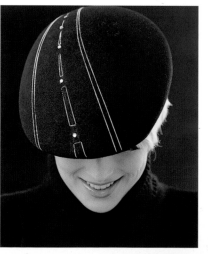

BRIGHT IDEA
Dark fabric curtains can make an impromptu backdrop if you don't have a proper one. Fine for a shot at home with relatives, not so good for taking to the mall with you.

▶ (Right) This moody shot used a 28–100mm lens at full zoom to knock out the background apart from the sinister-looking bars. This was shot at ISO 400 in bright sunlight using a small aperture to accentuate shadows and light. Desaturation and a tweak in Levels emphasized the graphic contrast. Photo: Chris Middleton.

▼ (Below) This shot was lit by a pair of halogen spotlights at ISO 1600 on a "Night" preset. Again, the image was desaturated and tweaked in Levels then afterward in Curves. Photo: Chris Middleton.

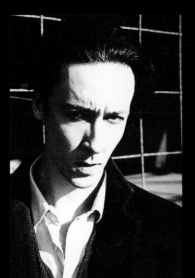

▲ Here black and white pulls the subject out of the background and throws all the visual emphasis on his clean-cut looks and pale eyes. Shot with a fast ISO this has then been desaturated and the Levels tweaked to ensure a good spread of tone. Photo: Lizzie Patterson.

INFORMAL STYLING

The opposite of formal, traditional portraits is the modern, informally styled image, one that conveys a more contemporary lifestyle approach. The subject should wear clothes that are both casual and yet their favorite type of outfit. That way they can relax and express themselves in front of the camera. It needs a light-hearted approach all round to encourage the subject to relax, but you still need to assess them to see what works and what doesn't work for their body shape and type. Then casually guide the sitter into those positions.

SETTING IT UP

For a casual-style photo, you really shouldn't be too complex with the lighting. It's just that the more complex the setup, the less freedom of movement the subject has, and the more static and tense they will get. The obvious setup is therefore to use two large softboxes on either side of the camera so that the subject can move around the target area, adopting different positions, and you can change the camera angle without worrying about losing highlights, etc. Set the lights to high power, of f/16 or f/22, so that you can shoot with lots of depth of field, as both the subject and you are moving.

POSING THE SUBJECT

Just because this is an informal, light, and easy style doesn't mean you can't show your sitter in the best possible composition. If your subject has wide hips, don't shoot them straight on, get them to turn a little one way. If they have a double chin, or a receding chin, get the camera higher and shoot downwards more. Make the most of obvious assets. Long legs? Get down low and shoot up. Quirky character? Get them to do more unusual poses. Mix it up, get them to relax, and have fun!

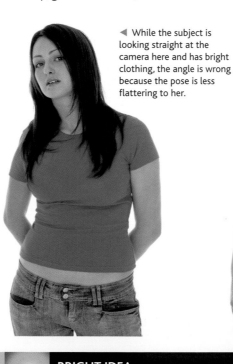

◄ While the subject is looking straight at the camera here and has bright clothing, the angle is wrong because the pose is less flattering to her.

▼ This is a more flattering pose with the subject angled away from the lens. However, she looks too serious and self-conscious and is clearly not comfortable with being photographed. Not everyone likes being photographed. The solution? Find a way to make the experience fun and catch her offguard.

BRIGHT IDEA
As this is a fun and relaxed type of shoot, why not have some music playing in the background. Ensure that it's something light and pop-orientated, to keep the mood light.

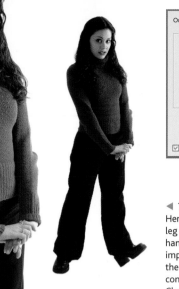

Output Channel:	Gray	▼		OK
Source Channels				Cancel
Red:		30	%	Load…
Green:		40	%	Save…
Blue:		30	%	☑ Preview
Constant:		0	%	
☑ Monochrome				

▶ Here the subject thought that the shoot was over and relaxed into her normal character—as is often the case with camera-shy people, or friends who don't believe they are photogenic (probably because they look awkward and unhappy in pictures!) Making her laugh when she was relaxed enabled some extra shots to be fired when she thought the camera was switched off, grabbing an effortless and flattering informal shot.

◀ This subject has an offbeat nature. Here she was photographed rocking one leg on the shoe heel and stretching her hands out. For this shot, eye contact was important to connect to the viewer. If the colors aren't that exciting, you can convert to monochrome with the Channel Mixer and brighten in Curves. If your subject is camera shy, like here, get them to play up to it and make that the subject of your portrait!

▶ This portrait shows how people's relationships with their pets work well in accentuating character in informal shots, whether the shot is posed or completely candid. Note how the sweep of his arm frames the shot. Photo: Lizzie Patterson.

TOOLS AT A GLANCE
- IMAGE > ADJUSTMENTS > CHANNEL MIXER
- IMAGE > ADJUSTMENTS > CURVES

INFORMAL ASSIGNMENT: CROPPING

Your assignment here is a little different, because we're going to explore the fact that there are many different ways to present a simple portrait by cropping it and scaling it up or down within the frame. Choose a portrait that offers slightly more than a full-face shot, and try six to ten different crops and scales to reveal a host of images within your original portrait.

SETTING IT UP

For parts of this exercise it will help to imagine your image divided up into a nine-square grid. This useful compositional technique is known as the "rule of thirds." It states that you can align the key elements within your image with any intersection on this grid and it will create a strong composition. This is a useful antidote to inexperienced photographers' belief that, in portraits, the face must be in the center of the frame and all of the sitter's head has to be in the shot. This isn't the case, and if you leaf through any magazine you'll see more radical crops—although there's nothing wrong with a simple, centered head shot.

 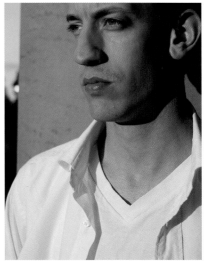

01 Here's our starting point: not a bad image, by any means, taken in the flattering warm light of the "golden hour" before sunset when the sun is low on the horizon. All the elements are here, so let's see if we can find alternative crops to create a different image.

02 Scaling the image up by about ten per cent and shifting the eye level nearer the top of the frame creates a less "centered" feel to the portrait, and it feels slightly more "commanding" and perhaps holds the viewer's attention more than the original crop.

03 The image is nudged further upward in the frame so his face dominates the top third of the image. This creates a strong diagonal line from the top right-hand corner down the line of his ear, through his chin and ending in the fold of his shirt in the bottom left.

BRIGHT IDEA

You can explore even more radical crops and still create stunning images: try cropping a full-face shot that has strong eye contact down the middle of the subject's nose and zooming right in within the frame to create a striking and unusual portrait of half the face.

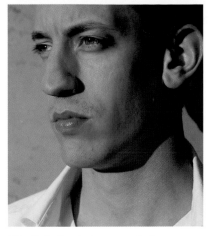

TOP TIP
Use the principles you've learned on this spread as a starting point for rethinking the way you look through the viewfinder and compose your shots. Look for themes, strong angles, and dynamic compositions from the outset.

04 Scaling the image up a further ten per cent and dragging the image left within the frame loses the sky and street lights and creates a powerful study in gold—changing the meaning of the portrait. Note the strong diagonal and the contrast between the dark top right and the light bottom left.

05 This crop makes overt use of the rule of thirds, dividing the image into three vertical stripes, while his neck and facial features lie on the horizontal thirds of the grid. Although this is a rather unusual, non-traditional crop, it still works because of the underlying logic of the composition.

06 Zooming in by a further 15% really makes his face the focus of the shot, and the light on his face and the pillar behind create a pleasing, painterly, almost monochromatic effect. A quick check in Photoshop reveals that, at this size on the page, the image is only at 60% of the original image dimensions.

07 When scaling images up keep note of the original dimensions. Scaling much beyond 30% larger than the actual dimensions will begin to degrade the quality of the image. Here, though, we are still only at 80% of the original dimensions of the image.

08 Here the image remains sharp despite having been scaled to 110%. By closely cropping in on the face, the subject of the image has become our model's expression and mood, and this invites our interpretation.

TOOLS AT A GLANCE
- IMAGE > CROP

ARRANGING GROUPS

If you thought sorting out poses and lighting for one person was hard enough, just throw a couple of extra people into the mix for a group shot. Arranging groups is a skill all on its own, whereby all the individual elements must be arranged so that the whole shape works. Then the expressions must match the overall mood, complement each other, or contrast in a meaningful way.

▼ With a large window casting light down onto a table, the mother and daughter, wearing evening attire, pose across and meet in the middle. This is a clever construct by photographer John Peristiany, placing the focal point centrally, yet having depth and width because each person leads off to the side.

SETTING IT UP

This is the lighting setup for the image below. Because there are lots of people in a group shot, the safest way to light it is to use lots of light and ensure that it is even across the range of the photo. In this case, it's an interior shot with one window light behind the photographer and the two subjects meet in the middle where it is brightest. Stand 6–10 feet (2–3m) back and use a short telephoto lens to compose the image tightly.

CONFIGURING POSES

The traditional way of arranging family members is to put the smallest at the front and arrange behind them, much in the fashion of the school photo. However, as long as you fill the frame, you can have people in any order, because all the space is being used and an odd shape isn't being presented. If there are more than four people in the photo, and you want a landscape-orientated shot, then you need to arrange them sympathetically. Either build to a point height-wise in the middle, forming a pyramid shape, or make it deliberately uneven, going tall, short, tall, short.

BRIGHT IDEA
Use props such as toys, MP3 players, and sports gear to give people things to hold and do if they are uncomfortable and don't know where to put their hands.

▼ This is a classic arrangement, showing both younger children at the front, along with a prop to fill the space, and their dad at the back. It also forms a pyramid-shape, which will rarely let you down with group portraiture. Photo: Howard Dion.

◄ Howard Dion shot this image of a father and his two daughters against a white background, with diffused natural light. The success of this shot is in filling the frame, and capturing the happiness of the girls and the love of their father.

TOP TIP
To isolate people from a background so that they stand out, as in Howard Dion's pictures, shoot against a white background, then use adjustment Curves and layer masks to white out the background completely.

▲ These are Howard Dion's grandchildren and the dramatic feature of this shot is the way they are all arranged into a vertical structure. The crucial element is that you can clearly see all their faces. Placing the smallest child between two older ones balances it nicely.

TOOLS AT A GLANCE
- LAYER > NEW ADJUSTMENT LAYER > CURVES

GROUP ASSIGNMENT: THE FAMILY PORTRAIT

Photographing families has a different dynamic from photographing groups in general. There are two key elements that must be present in the shot, in this, your family group assignment. This can be a shot of your family or one of friends, but the people in it must look happy and, or, excited. Remember, if this is going to sit on someone's living-room shelf, no one wants to look at a picture of people looking moody. The second element is one of closeness. You must attempt to convey the joy that parents have for a newborn child, or the love they have for their young children, by their proximity.

SETTING IT UP

The main picture opposite was setup by having the parents sit on the sofa, with the camera on a tripod in front of them. A flashgun was fired at the ceiling to bounce light back down in a soft, diffuse fashion. It was also less stressful for a baby than having a flashgun go off in its face. Howard Dion was the man shooting this portrait, and he spent ten minutes having the couple talk about their baby to get them to relax enough.

SHAPES AND ORDER

Physical proximity is something you should aim for. One of the most important elements of the family picture is people's faces, so not only should they be easy to see, but you should use the faces to make shapes within the picture, rather than the bodies themselves. Look for pyramids, curves, and circles of faces to make the picture work.

▼ This is Howard Dion's son with his wife and their son. What comes across here is the closeness of the family unit, and the fun they have with the child.

▲ In this shot, two more children join the pose, and Howard Dion has skillfully arranged all the faces in a circular grouping in the middle of the photo. You are immediately drawn right into the thick of the composition.

BRIGHT IDEA
Do you know friends who have just had a baby? Offer to make a print for them so that you can practice your technique on them without the pressure of having to do it on a paid shoot for the first time.

TOP TIP

Because you want spontaneity in photos like these, it can be tricky to keep everything in sharp focus. For that reason, when shooting against a plain background, set the aperture to f/11 so that you get a reasonable depth of field, keeping everyone in focus throughout the image.

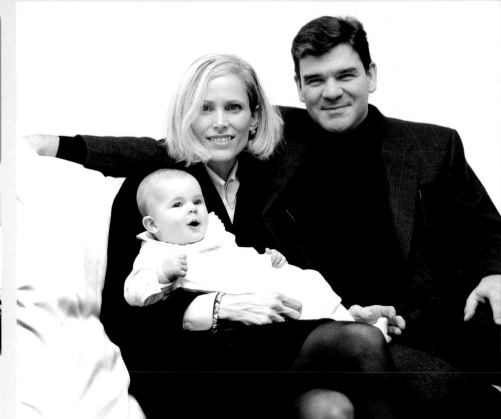

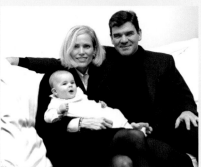

01 Here's the original image of the main picture, shot in color. Howard Dion always intended that it should be converted to a high-key monochrome, therefore flooding the background with light.

02 Once converted, this charming image of the couple and their new baby was printed out at 11x14 inches (28x35 cm), matted and framed, and given as a gift. It's now hanging in their living room.

03 Firstly the image was converted to monochrome by going to Image > Mode > Grayscale.

04 The Image > Adjustments >Highlights/Shadows function was used to brighten the shadow areas a little, to make the picture lighter.

05 Finally, the Dodge tool was used, at 100% exposure, and a 200-pixel brush, to whiten out the sofa on the right-hand side of the image.

TOOLS AT A GLANCE
- IMAGE > MODE > GREYSCALE
- IMAGE > ADJUSTMENTS > HIGHLIGHTS/SHADOWS
- DODGE BRUSH

INSPIRATIONS—THE BEST OF PORTRAIT TYPES

The length of the portrait you shoot changes the impact of the face, the relevance of the surroundings, and the ease with which you can pose the subject. Even the same person, in the same location, can give a completely different meaning, depending on the length of shot chosen.

▶ A full-length shot with a difference. The model is actually lying on the floor and the camera is above, and past the head, tilted to look back down the length of the model. Not easy to shoot, it gives a very unusual full-length perspective, yet still focuses on the face to make it more immediate to the viewer.

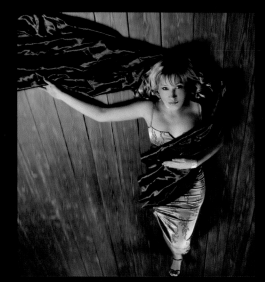

▼ This shot by David Sams, in an open courtyard, is a head-and-shoulders shot, but taken to an extreme. Great use is made of the texture of the flooring, and with the subject being placed in a radical position, the impact and design of the shot are significant.

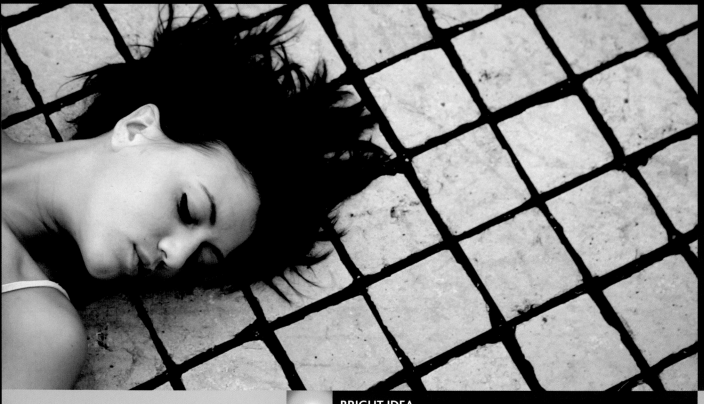

BRIGHT IDEA
Try shooting a subject using all the lengths of shot available, just to compare the difference it can make and how much harder you have to work as you reach the full-length shot.

▲ Using natural light from a window high above, and a small reflector to the left of the camera, John Peristiany of France has turned this head-and-shoulders, plus extras, into a thoughtful and sensitive portrait.

▶ How to make a full-length shot seem dynamic and full of interesting angles. Firstly, Simon Pole has angled the camera, then the model is leaning back and sitting up to provide an interesting shape. The lighting has been designed to fill the main areas of the pose with light, while a fill light on the opposite side ensures that the shadows are not too severe.

4 LOCATION SHOOTS

Shooting on location requires a wholly different raft of skills from working in the studio. You have to be able to use the light effectively and supplement it when required, organize the shoot efficiently, and manage the subject and any passers-by who stray into the shot. Those are just the elements to tackle on the day. Before you get that far you have to scout out urban and rural locations, figure out how to shoot in extreme lighting conditions, and understand how to capture action shots on the go.

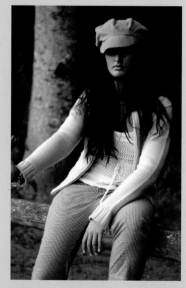

▲ You can use locations as a means of adding meaning to shoots, like this fashion-catalog-style shot.

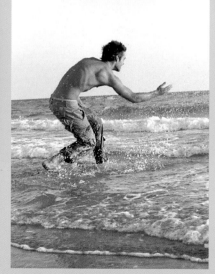

▲ Seafront locations are an excellent environment in which to shoot people relaxing and at play. Photo: Lizzie Patterson.

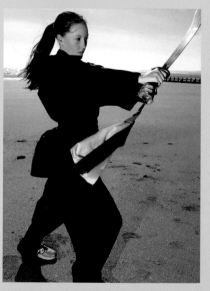

▲ Seafronts are also locations that attract a wide range of people engaged in unusual activities and sports.

▼ Sports locations, like this athletics track, are ideal places to capture people's passions for what they do—and make great action shots.

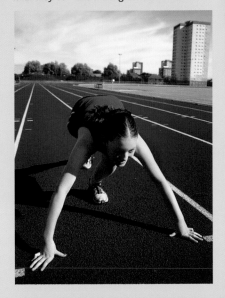

▲ Expansive landscapes offer an ideal opportunity to take portraits of people that have real drama and visual impact, as they capture human beings against the elements.

▲ Other locations can be used to create texture and a visual context for truly characterful portraits that suggest a wider story. Photo: Howard Dion.

INSPIRATIONAL URBAN LOCATIONS

Shooting in big towns and cities, whether they are historic, ultramodern, or as quaint as a picture postcard, offers a wide variety of backdrops for the portrait photographer to shoot against. However, how you frame the subject against an urban backdrop will radicallly change the meaning of the portrait, as we can see from these simple, easy-to-copy examples.

> **TOP TIP**
> It's easy to take pictures of historic buildings and familiar landmarks, but think about how else you can use a city to add new dimensions to a portrait of a human being: tell a story with the location.

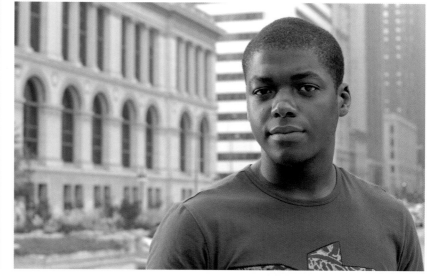

▲ The neon lights of a city at night are blurred in the background of this portrait—an example of using an urban location purely to tell us something further about the character of the subject rather than as a picturesque shot of architecture. Photo: Chris Middleton.

▶ This shot is pulled back to show a woman against a backdrop of a busy city. By showing her close to the camera but looking away, and with the city all around her, the photographer is saying that she and the city are of equal importance. She has a role to play in it, perhaps—a story to tell.

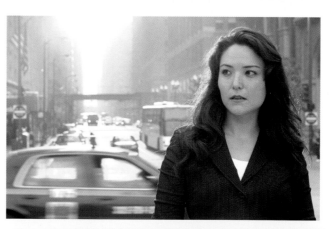

▲ This boy is a picture of someone at home in New York. Placing him close and using the buildings as context tells us that the character of the city is in the subject's face as much as it is in the buildings—thanks to his confident eye contact.

BRIGHT IDEA
Even in the middle of the city, petty crooks will pick up and walk off with bags behind your back. Try to ensure that you either have a chaperone for the model or a friend to watch your equipment.

BE SECURITY CONSCIOUS!

If you shoot in cities and towns you will always draw attention, so be streetwise and beware of attracting trouble or opportunistic thieves. You need to be thick-skinned and prepared to deal with unwelcome attention.

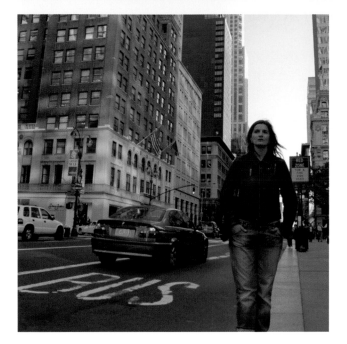

▶ High-rise, heavily built-up areas in major cities can seem impersonal and isolating. This simple, distant shot implies a story about the woman, who looks as though she could vanish into the streets. Photo: Jason Keith.

▼ Cities can also be about chic living. Here the freedom and independence of the big skies high above the bustling streets is captured with a low, wide angle. Photo: Jason Keith.

URBAN ASSIGNMENT

If you look around any city or town, of any size, there are areas that are grimy. Whether it's an estate, a tenement block, an industrial park or just some forgotten alley full of yesterday's paper, beer cans, and trash, you can rely on the urban sprawl throwing up a gritty corner somewhere. Your assignment is to make a fashion statement by sending your subject, boy or girl, into the city wearing their best prom dress or suit. Contrast youthful energy and clothing with urban decay and detritus. Convert it to monochrome for high-contrast black and white.

SETTING IT UP

It's worth scouting for locations that are both gritty and yet relatively safe for you to photograph in. There's little point in shooting photos if you are mugged for your efforts. Find an alley and get the subject to look refined. It might well be dark and dingy, so bring a flashgun along—the idea is to contrast the two, not blend them together in the dark. Stand about 10 feet back with a 28-70mm telephoto lens and look to shoot around the three-quarter-length body.

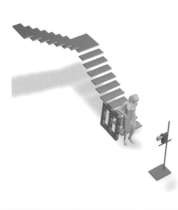

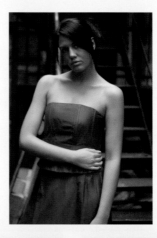

◀ This isn't bad. We've got the girl looking elegant, but the face is in a little too much shadow and there's probably not enough background detail.

▼ The same kind of pose, but now with more background and more of the face in the light. Even under natural light, it was possible to develop enough contrast in the image. This would certainly be a contender.

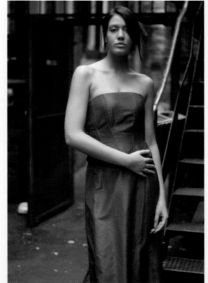

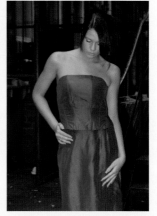

▲ We've now tried out the flashgun which has lit up the subject and separated her from the background. However, the looking-down pose is all wrong and the background has become muddled.

BRIGHT IDEA

One of the choices that will help you find your "voice" or signature style as a photographer is whether to use background to directly complement your subject's personality, or use it as an intriguing contrast to your subject—showing their character "in relief," as it were.

TOP TIP

Use fill-flash rather than an automatic blast of light from the flashgun. If it has a manual setting, use it to dial-in a low-power setting. Just enough to light up the outfit and put a catchlight in the model's eyes.

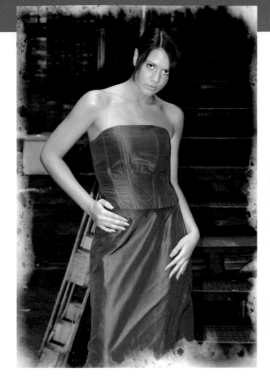

▶ This is the shot we want. The model is brightly lit and making good eye contact. There's an elegant pose against a backdrop of rubbish and grime. The staircase on the right adds an extra element by disappearing up and offscreen. Now let's see how it can be processed in Photoshop.

01 First the image was converted to mono using the Channel Mixer.

02 Then the Levels were adjusted so that the tones used the full range available.

03 The highlights were bright enough, but the shadow detail was too light so Curves was used to darken them.

04 Finally an acid etch border was added using Extensis PhotoFrame plug-in.

TOOLS AT A GLANCE
- IMAGE > ADJUSTMENTS > CHANNEL MIXER
- IMAGE ADJUSTMENTS > LEVELS
- IMAGE > ADJUSTMENTS > CURVES
- FILTER > EXTENSIS > PHOTOFRAME

INSPIRATIONAL RURAL LOCATIONS

There are many advantages to shooting in the countryside: landscapes and vistas you rarely find in cities, the intricate patterns of nature, and the beautiful colors of the changing seasons. These are all good reasons for making them the context of some inspired portraits of people in the natural world.

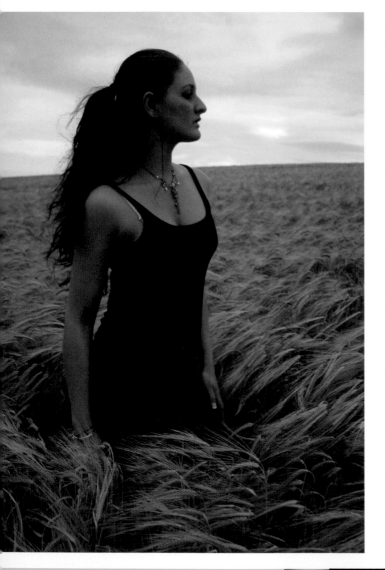

◀ Fields of crops offer vistas of repeating patterns that lead to the horizon. Get there on a windy day and the effects will be even more striking.

▼ This portrait of a girl in a forest uses the natural world as inspiration as well as backdrop for a dream-like, "fairy princess" style shot.

SETTING IT UP (FACING PAGE)

Setting up the shot of this girl was very easy once on location. A 50mm prime lens was used with a wide open aperture of f/1.8 because light levels were so low. This threw the background out of focus. The camera was about 12 feet (3.6m) away and the light was very diffuse, coming through a thick canopy of leaves.

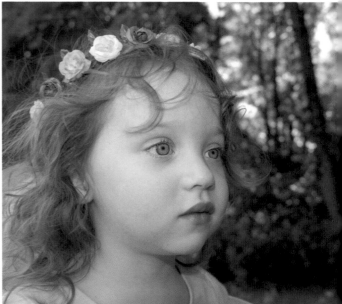

BRIGHT IDEA

A good map will not just show you how to get to places, it should also have scenic or historical features marked on it, making it easier to select unusual destinations to visit and include in your portrait work.

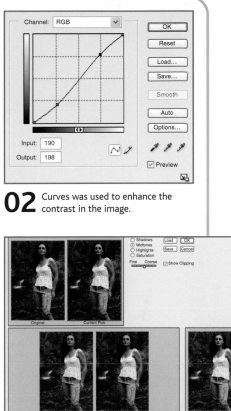

02 Curves was used to enhance the contrast in the image.

▲ The woodland stream is the classic rural location. Though there will be other walkers treading the same paths, you can generally shoot without anyone in the background, and the combination of peasant or country-style clothes with a woodland backdrop is unbeatable.

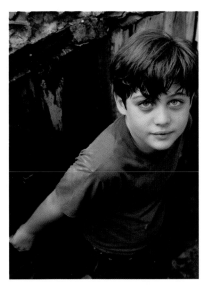

▲ This striking image of a young Cuban boy outside a rural cottage makes good use of the rough, dark textures of the building contrasted with the simple, bold color of his top. Photo: Lizzie Patterson.

TOP TIP
Use rural settings both to capture the landscapes as a backdrop, but also to contrast natural textures with the subject of the portait.

01 As it was shot in dark conditions, but the model had a white top on, this image was deliberately underexposed by 1 stop. This required Levels to spread the tones out.

03 The image was shot with a white balance setting that would make it look warm. You could use Variations with a blue selection to cancel that out, or enhance the rustic coloring by adding a red tint, as was done here.

TOOLS AT A GLANCE
- IMAGE > ADJUSTMENTS > LEVELS
- IMAGE > ADJUSTMENTS > CURVES
- IMAGE > ADJUSTMENTS > VARIATIONS

RURAL ASSIGNMENT: COUNTRY LIFESTYLE

You have been commissioned by a country lifestyle magazine to produce the lead photo for an article. This type of magazine caters to fairly affluent readers, so the model must have a classy, timeless look, and styling is everything. The introductory text to the article will only be the headline and standfirst across the bottom of the image, so you must avoid placing anything crucial there.

STYLING

Start with something in tweed, but don't overdo it. It should be trendy, yet classy. For our model here we have tweed pants, green wellies, a shirt, a top that goes over it, and a cardigan. She is wearing a jaunty hat and we rummaged around for a stick to carry. On one of the alternative shots she has jodhpur-style pants and a wool-knit blouse.

SETTING IT UP

Locate a spot where a track leads off into a wooded area. Set the model back about 50 feet (15m) and use a telephoto lens—around 200mm to frame her. You can also try using a 50mm lens for some closeup shots and attempt to sell those to the magazine while you are at it. Use a wide-open aperture to throw the background out of focus. Light should be filtered through the trees, so shoot during the middle of the day or it will be too dark.

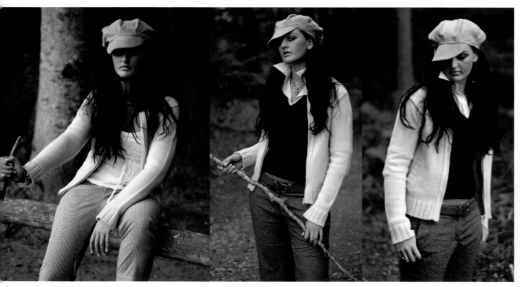

▲ This is the shot wearing alternative clothing. It has the required casual, fashion look to it and there is plenty of room at the bottom.

▲ This shot has a good composition with the angled stick, but the expression on the model's face is not right for the purpose of this shot and the eye-makeup is too prominent.

▲ While this is a useful shot, it's probably one for the portfolio as the hands would be right under any text, and the angle of the head would make it look as if the model was reading it.

BRIGHT IDEA
Pick up country style and lifestyle magazines for inspiration for your work and compare and contrast what makes the images work for the market—analyze the lighting, the spread of tones, and the way the subjects are shot against the rural backdrops.

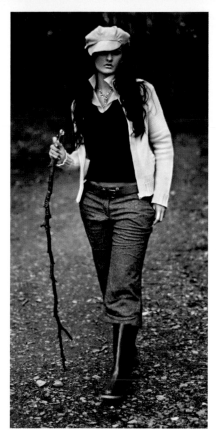

03 The contrast was enhanced with an S-shape Curves function.

04 To add real depth of contrast, the Unsharp Mask filter was used on a duplicate layer with a Radius of 50.

05 This tends to burn out the white detail, so these areas were, once again, masked off.

01 This is our shot. Casual, yet classy, and all done in a country style with plenty of room for the title—the strong eye-makeup makes the eyes visible beneath the cap.

02 To get it to that stage a Levels adjustment layer was used to brighten the image. The cardigan and lapels were masked off to stop burning out.

> ### TOP TIP
> Using a wide aperture is the key to all these photos, but it may still be a little gloomy. Bring a tripod to ensure you can work at ISO 100 for maximum quality.

▲ This is an alternative, sepia/newspaper-toned version of the same image

TOOLS AT A GLANCE
- LEVELS ADJUSTMENT LAYER
- IMAGE > ADJUSTMENTS > CURVES
- DUPLICATE LAYER
- UNSHARP MASK
- LAYER MASK

SUNSET AND LATER

As the sun sets, it leads to challenging conditions for those taking portraits outside using natural light. It also offers a chance to use the deepening sky color and the blaze from the sunset to create more unusual portraits. The trick is to use a flashgun, but it must be controllable—just setting the camera and the flashgun on automatic won't get you the right result.

TOP TIP
The idea of using Aperture Priority mode with the flash is that some flash units will fire at the subject until the light bouncing back has reached what the flashgun thinks is the right level. Then it cuts off. The camera shutter meanwhile stays open to record background light.

▲ There are three parts to this image, and you can't get all of them at one go, so what we have here is the sunset and the subject, leaving the ground detail disappearing into shadow. The ambient light was metered for the sunset, so that it would be recorded, which threw the landscape into shadow. The flashgun was then set to be bright enough to light the model.

SETTING IT UP

Set the subject in front of the background you want to record, but ensure there is a good gap between them and any immediate background objects so that you don't get a large shadow on them from the flashgun. Stand around 6–10 feet (2–3m) away, with an 18–50mm wide-angle zoom lens, so you have flexibility with the shot. Set the aperture to f/8 and your flashgun accordingly—see below. Shoot to record both the subject and the background.

WORKING THE EXPOSURE

This is a technical challenge first and foremost. To record the background or ambient light, use the metering in your camera. You don't want excessive depth of field, and in any case, it will probably make the exposure very difficult. So, set your camera to f/8 in Aperture Priority mode and focus on the background, not on your subject. Take the reading—this is the ambient light. Now, how you proceed depends on how your flashgun works. You might be able to simply set the camera in AP mode with f/8 aperture with the flash on. Use manual focusing so that you don't accidentally meter off the subject. However, you might also have to put the camera into Manual mode with the readings you've taken, then set the flashgun to produce enough power to light the subject.

BRIGHT IDEA
It's worth checking out the exact working parameters of your flashgun, whether that's an independent device or one that's built-in, so that you can see how much control over it you have. Then go experiment with it.

▶ Shots like this can be very powerful, as they show a human being silhouetted against the setting sun, with the golden light reflected off the waves. The lower the angle is on seafront shots, the more successful the image will be as it creates a "stage" for a strong composition and study of form.

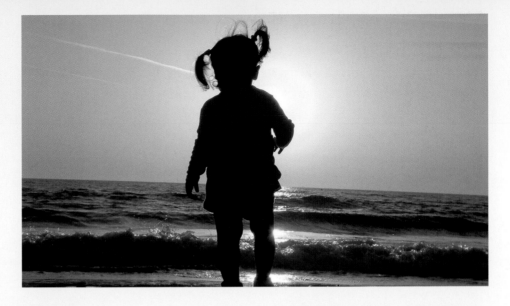

01 This is done without using flash at all. The subjects had to stand very still as this was a four-second exposure. The camera is on a tripod so the castle comes out sharp, but there is obviously some blurring of the figures. Note that because there is so little light, the Automatic White Balance cannot cope and the figures are rendered with the same color cast as the castle.

02 In fact, they were then masked off and color balance used to make them less red than the original exposure. This is why we use flash in low-light situations.

TOOLS AT A GLANCE
- IMAGE > ADJUSTMENTS > COLOR BALANCE

MIDDAY ASSIGNMENT: PERFUME ADVERT

There's a new perfume fragrance coming onto the market from a low-cost, value-end rated manufacturer. They want you to shoot some pictures for an advertising campaign, both in portrait format and in landscape format so that the picture can be used across a double-page spread. On all of them, there have to be places where the bottle of perfume and some text can be added. The extra requirement for the double-page spread is that there is lots of room to go really into depth about the product and where customers can get it from, so it must be interesting, but largely empty.

SETTING IT UP

There's a range of shots here, from a telephoto shot of the girl in the distance, to a head-and-shoulders shot with a 50mm prime lens and shots that fill the frame. These last images were shot with an 18–50mm short telephoto lens. For the shot of the girl leaping, the camera was 10 feet (3m) away and she jumped on a count of three. An aperture of f/8 was used to ensure sharpness, and a shutter speed of $^1/_{250}$ captured the moment. The wide-angle telephoto lens was around the 20mm setting to capture the entire scene.

CONCEPT

The product name will be something along the lines of "Abandon," so the photography needs to match phrases like "Abandon yourself" and "Give in to Abandon." So wild, windy, desolate, yet bright and youthful. We shot this in some large sweeping sand dunes on a bright, windy day.

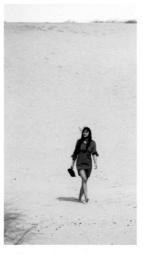

▲ The massive sand dune provides an empty background, though perhaps all the footprints do make it look a little busier than the photo would suggest. This is the weakest of the shots because, while there is plenty of space for words and a bottle, the figure is a little small and the positioning makes it difficult to use the bottom half of the picture.

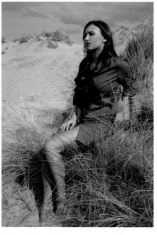

▲ This is ideal and was shot with the wide-angle telephoto lens. The light is above and to the right, so the model doesn't have to look into it. The angle of the model makes for a dynamic picture and there is room in the top left and bottom right to add graphics and words.

▼ This is the shot for the spread. It fits the bill perfectly, yet leaves acres of room on the left side for the bottle graphic, the catchlines, and a list of suppliers.

BRIGHT IDEA

Be mindful of the colors used in the clothing and styling. Orange goes well with sand dunes and the concept, but it is a poor color to convert to CMYK, which is what will have to be done for use in commercial printing. So avoid bright, neon colors.

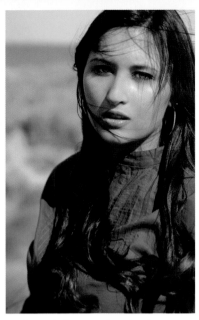

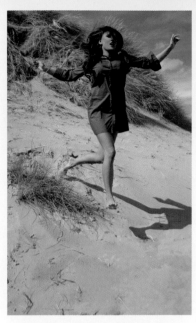

▲ Shot with the 50mm lens, this shows the windswept model up close. Although the picture looks full, the key area is the face, leaving the entire bottom half available to put a gray background box over, and then the graphics and text.

▲ Suggesting the theme of freedom and abandonment, the model is leaping into the air, being snapped at the midpoint. With windy conditions, you'll need to shoot this a few times because the expression can be wrong, the arms in the wrong place, hair in the mouth, etc.

01 On bright days, facing reflective sand, underexposure is common, even if not deliberately done to avoid losing highlights.

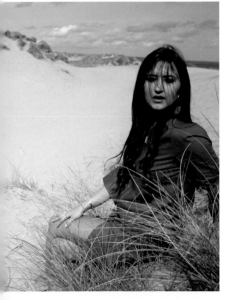

02 After a couple of jumps, the landing zone will look a mess. Use the Clone Stamp tool at 100% Opacity to fill the footprints in.

03 With sand and greenery, you'll want to make it look as radiant as possible. Increase the saturation accordingly.

TOOLS AT A GLANCE
- IMAGE > ADJUSTMENTS > LEVELS
- CLONE STAMP
- IMAGE > ADJUSTMENTS > HUE/SATURATION

INSPIRATIONS: TELLING A STORY WITH LOCATION

The use of the location in exterior photography can determine the feel and set the tone, at the least. It can also be used to create a narrative for the photo—in effect, creating a story using the location. The objective for the photographer is to find the right location to tell the story that you want.

USING SCALE

The biggest challenge with an exterior location is one of scale. Place a person at the bottom of a mountain and stand well back and all you get is a picture of a mountain with a dot at the bottom. The trick is either to use only that part of the location that is necessary for the story, or to shoot it from such an angle that you capture both the person and the key element of the background that made it worth using in the first place.

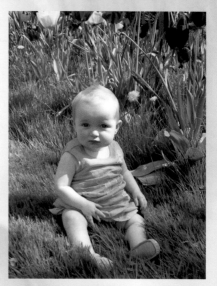

▲ We've all got photos like this in the family album—but they can be excellent examples of portraiture for the simple reason that they become so familiar, we return to them, and they help us to write and retell the stories of own childhoods. Photo: Iain Gibbons

▼ This picture shows a teenage garbage collector in the Punjab scouting for bits of junk to turn into cash. Photo: Paul Rains.

BRIGHT IDEA
The tourist information service of any town or city will provide you with a list of historical locations. Go check them out for photographic potential.

◀ Transport makes a good narrative device. Here are two cleaners waiting for the Tokyo bullet train to come to a halt, their stillness contrasted with the motion of the train.

▼ (Above) It is easy to dismiss images when we encounter so many of them. This is not the most inspiring shot in the world, at first glance, but it is one that reveals a great deal of character if we spend time looking deeper into the image.

▲ (Below) A fresh face in a bracing winter landscape might seem a simple shot, but take care that your camera doesn't record snow as a murky gray: use the Exposure Compensation feature and adjust by a stop or two and preview.

▲ Sitting outside a café with a cup of tea or coffee can make for instant lifestyle images. Go for a close, dynamic crop to concentrate on this aspect, or pull back and add extra background to develop the story.

INSPIRATIONS: YOUTH MAGAZINES AND CATALOGS

Youth magazines and aspirational clothing catalogs for young
people cover a broad array of styles, from the simple, classic and
childlike, to the sophisticated tastes of young adults—via the
attitude-filled pages of teen magazines. Rapidly changing tastes
make these among the hardest portraits to get right.

TARGET MARKETS

Young people change so quickly and
images that appeal to them at the age of
11 or 12 will be completely wrong within
a year or two, and wrong again as they
move into their later teens and young
adulthood. Here we're showing you a
trio of shots that hit the right mark at
each stage of the journey, to give you
some idea of the range of issues and
challenges you're likely to face if you
want to shoot portraits of (and for)
young people on an amateur level, or
on a more professional basis. The key to
successful images of young people is
to avoid imposing your vision of how
you believe their lives should be.

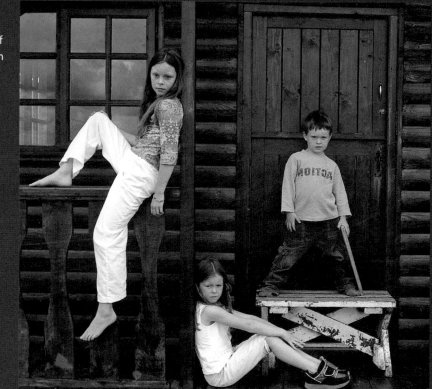

▲ This posed but stylish "catalog" shot
doesn't try to portray these young people as
adults, but it does show them in a mature and
very sophisticated way, making good use of
location. It will strongly appeal to them, and
also to parents. Photo: Lizzie Patterson.

BRIGHT IDEA
Don't try to present children as small adults, and try to avoid the temptation to shoot
clichéd images. Ask them how they would like to be photographed and see what ideas
they come up with. They may be more imaginative than you!

▲ (Above) This lovely shot is perfect for the arrival at young adulthood, showcasing natural style, confidence, and fun, with the clothing incidental to the statement about the wearer. Photo: Lizzie Patterson.

▶ (Right) This is an edgier, urban shot that might appear in some of the more cutting-edge style magazines, showing real street fashion in real cities rather than a collection you'd find on the runways of haute couture.

ACTION PORTRAITS

Sporting events, races, and even action-oriented hobbies all make interesting and colorful subjects for portraits. It can be as simple as a record shot of the event taking place, something to send to the local paper, as contrived as someone practicing a hobby in full gear, or a creative shot of a horse or cycle race, where the subjects are completely unaware that they are being photographed.

01 To grab a shot like this you'll need a fairly fast shutter speed to freeze the action without any blur, plus a wide aperture. The other ingredient will be patience on your part, —and your model's!

SHUTTER SPEEDS

While aperture can be important, in this class of photography it's what you do with the shutter speed that counts most. If you want to freeze the action dead, then you need $1/250$ sec for slow-moving events, up to $1/500$ and $1/1000$ sec for fast ones. Also, the closer the subject is to you, the faster the shutter speed will need to be to freeze them in place. For a car screaming past you on a track, something more like $1/2000$ or $1/4000$ might be more appropriate. To get these kind of fast shutter speeds, the payoff is that you will be using wide-open apertures so you can forget about any depth of field. The flipside of this is to use slower shutter speeds to deliberately blur the action, which, strangely, can give the impression of speed much more effectively.

02 Kevin Wylie shot this picture of a fast-moving horse, using a very slow shutter speed of $1/8$ sec, but used second curtain flash to bring detail and brightness to the shot at the end of the exposure.

03 A similar technique was used again by Kevin Wylie on this shot, where the shutter speed was even slower at $1/4$ sec. As the boxer's hands were moving very quickly, all the flash picked up was the impression of the face, torso, and punchbag.

BRIGHT IDEA

Want to blur the action with a slow shutter speed, but don't want to have to use an aperture of f/22 because it's a bright day? Then fit a 4x or 8x Neutral Density filter to stop too much light coming in.

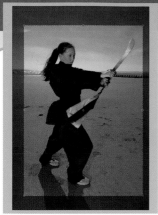

01
First this image was cropped to remove a little of the sun flare and produce a tighter composition.

02
Then Levels was used to stretch the tonal range, and Curves used to make the black of the outfit a deeper shade.

03
Finally, it was important for a shot like this to have plenty of sharpness, so the Unsharp Mask filter was used to add a little more bite and detail.

TOP TIP
The longer the lens you use, the greater the widest f-stop is likely to be, and instead of shooting with f/2.8, you may be using f/5.6. This will reduce the available shutter speed, perhaps critically. Your two options are either to buy a lens with a wide aperture at long focal lengths, (a "fast" lens), although these are expensive, or to increase the ISO rating and risk digital noise.

▲ In this photo, the subject was wearing a martial arts outfit and was going through a set of motions with a sword. She was positioned so that the sun was behind her, and flash was used to balance the exposure. The shutter speed was $^{1}/_{250}$ sec to synchronize with the Metz Megablitz flash, while an aperture of f/22 ensured the bright ambient light was recorded.

TOOLS AT A GLANCE
- CROP
- IMAGE > ADJUSTMENTS > LEVELS
- IMAGE > ADJUSTMENTS > CURVES
- FILTER > SHARPEN > UNSHARP MASK

ACTION ASSIGNMENT: TRACK RUNNER

A local athlete is trying to get sponsorship and comes to you with a brief to shoot some action portraits of her running and sprinting on the track. You'll also be shooting more classic portraits later, but this part of the assignment takes you out to the running track. You must capture the action in a variety of ways.

SETTING IT UP
You want a variety of different shots, so that means using different lenses. Use wide-angle lenses for abstract, creative shots, a telephoto lens for straight runs down the track, and a 50mm lens for closeup shots. Look for the direction of the sun and ensure that your shadow isn't in the shot. Get the subject to run right past your camera as you shoot.

SHUTTER SPEEDS
To freeze the action dead you'll need a fast shutter speed of $1/250$ or $1/500$ sec. This means throwing the aperture wide open. Check the light and the speed you are getting. If they aren't fast enough, then increase the ISO to 200. For blurred shots that are more artistic, select the narrowest aperture of f/22 and, on a bright day, you will probably need a neutral density filter as well. Then, as the runner approaches, pan the camera while taking the shot.

▼ Use the wide angle lens and get close in as the runner prepares to set off. The wide angle will make the arms stretch out.

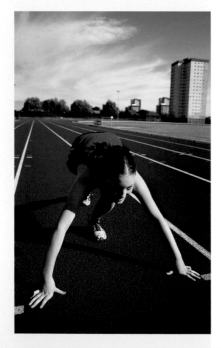

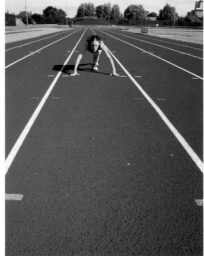

▲ This is an abstract interpretation. Shoot the wide angle at the other end of the track, focusing just in front of you. Use an f/22 aperture to get the subject as sharp as possible in the distance.

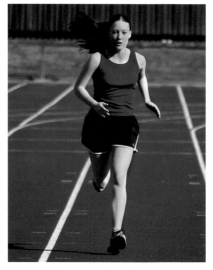

▲ Use a telephoto lens to capture the subject in motion, hammering down the track.

BRIGHT IDEA
Get the runner to wear a number of different colored tops. Then advise that those colors that specifically complement the logo of a would-be sponsor are used for each approach.

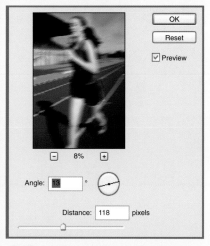

▲ Switch to a 50mm lens and get close up for a shot of the runner and her shirt. This is the chance to show the way sponsorship will be displayed.

TOP TIP

For an even more dramatic picture, lie down right next to the finishing line, use a wide-angle lens and manual focusing for a closeup shot as the runner races past.

01 Get close in with the wide-angle lens as the runner crosses the finishing line. Use filters and layers to give an impression of movement.

▲ Use text and reduce the opacity so that it blends into the fabric. Put it on a curve so that it looks more realistic.

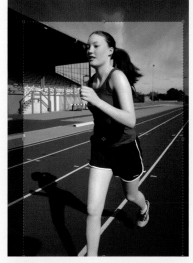

02 When the runner is hurtling past it's impossible to frame the picture accurately. Use the Crop tool to get it right.

OK
Reset
☑ Preview

⊟ 8% ⊞

Angle: 13 °

Distance: 118 pixels

03 Besides the usual Levels adjustment, create a duplicate layer and apply a motion blur to it. Add a layer mask and ensure the face is clearly visible.

TOOLS AT A GLANCE
- CROP TOOL
- IMAGE > ADJUSTMENT > LEVELS
- DUPLICATE LAYER

- FILTER > BLUR > MOTION BLUR
- LAYER MASK

INSPIRATIONS: THE BEST OF EXTERIOR LOCATIONS

When shooting portraits outside, the environment can be part of the photographic narrative, lending a meaning in conjunction with the styling of the person in it. Or, the scene can place and identify the subject, putting them into context. Finally, it might just be a nice background to shoot someone against. All these things are elements in a successful location shoot.

▶ This is the Dragon Master, the guide to the dragon ride at the carnival near Howard Dion's home in Florida. He operates the controls and makes sure the kids are the right height to go on the ride without a mom or dad. Dion says, "I struck up a conversation with him and he said he hates to have his picture taken because the pictures always turn out looking like the picture on a driver's license. I told him that his face was full of character and that if he let me photograph him, I would bring him a print. I promised to do better than the driver's license photographer. Afterward he told me he was going to send the color version to his sister, who hasn't seen him in 30 years. The black and white he was keeping for himself."

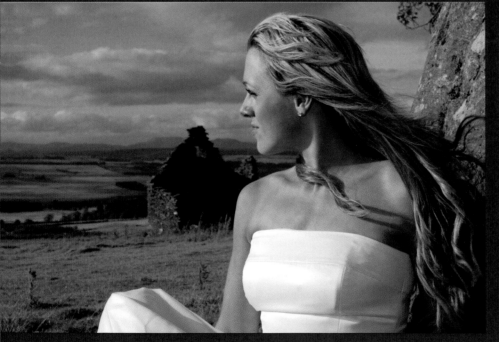

TOP TIP

Incorporate elements of the scene into your photos, but don't let them dominate the subject, unless you are aiming for a repressive or ominous feeling.

◀ Old, ruined buildings, particularly ones typical of the area, make fine backdrops, especially when set against something modern and lively, like a bride in her wedding dress, as Simon Pole illustrates here.

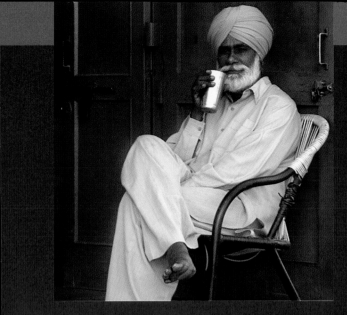

◀ Paul Rains was travelling through the Punjab in northern India when he spotted this gentleman drinking his morning tea, outside his house.

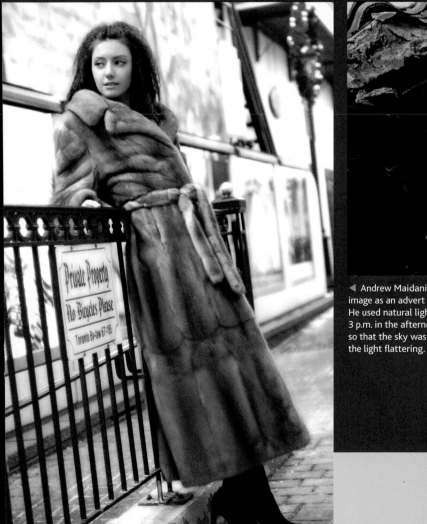

◀ Andrew Maidanik shot this image as an advert for a store. He used natural lighting, about 3 p.m. in the afternoon in winter, so that the sky was overcast and the light flattering.

▲ Photographer Lizzie Patterson shoots "try out" images for some of the world's top international modeling agencies, but she grabbed this photo of a young boy while on vacation in Cuba.

5 LIGHTING STYLES

How you use light, whether it is natural, from a window, or artificial like tungsten and electronic flash, determines what your picture looks like. If you master control of lighting, your pictures can be depicted the way you want, showing light and shadow in exactly the places you desire, and conveying an atmosphere, whether it is light and airy or dark and mysterious. Combining light sources is even more of an art form—one that can take your portraits to another dimension entirely.

▲ Bright sunlight and the stunning colors of the countryside always make for eye-catching portrait shots.

▲ Use lighting to create artifice, mimic genres, and achieve other striking effects as well as simply to illuminate your subject.

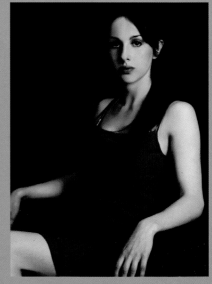

▲ Subtle, flattering lighting combined with intelligent use of color and shade can help create more sophisticated portraits.

▼ Single, directional light sources plus contrasty black and white can make for portraits that strongly emphasize texture, line, and form.

▲ Create pop-magazine effects by using bright colors and "high-key" exposure techniques that add a splash of energy and excitement.

▲ Use natural lighting and classy black and white to create elegant grayscale people pictures.

USING DAYLIGHT

Strange though it may seem, simple daylight offers more challenges, more variety, and more color than shooting using electronic flash in the studio. The color of light itself changes throughout the day, as well as the intensity, and all of this can be affected by cloud conditions and the location of the person you are photographing.

SETTING IT UP

To set up the shot in the heather, compose the model so that she is standing sideways on to the sun. Stand in the heather so that there is as much vegetation heading off into the distance as possible. Use a short telephoto lens, 35–70mm, and stand around 15 feet (4.5m) back. Now dial in −1EV exposure compensation to ensure that light skin tones are not lost in the sunlight. If the subject has blonde hair, it may be worth increasing the compensation further.

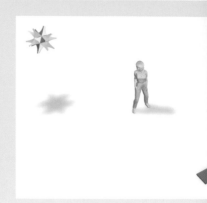

THE GOLDEN HOUR

The hour after sunrise and the hour before sunset are often referred to by photographers as the "golden hour". Here the sun is near the horizon and the light is coming vertically across, casting a golden orange light onto everything. Be warned that your digital camera AWB will attempt to tune this color out.

01 This photo was taken in bright and glaring sunlight. By cropping in really close, the photographer excluded the harsh light and captured the wonderful expression instead. Photo: Howard Dion.

02 Overcast days are both a boon and a bane. The boon part is that the light is soft and diffuse and you are unlikely to lose highlights through extreme exposures. The bad news is that the scenery will tend to look duller.

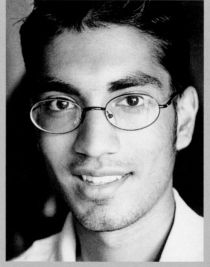

03 One way of getting deep shadows in daylight portraits is to shoot them in doorways, with the light hitting the subject but not the background. This was taken at a front door in daylight. Photo: Chris Middleton

BRIGHT IDEA
Try shooting the same scene using a variety of white balance settings to see what effect it has on the color of light recorded.

03
The saturation across the image was boosted using Hue/Saturation.

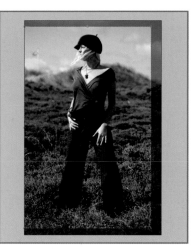

01
Shooting at midday when it is sunny is a real challenge. The exposure will be hard to capture without losing highlights, but the plus point is that the scenery, when captured digitally, comes alive. When the subject is looking in the general direction of the sunlight, it's best to have a hat or sunglasses on to provide shade. This pose was shot in the middle of a bank of purple heather.

04
As the subject is looking left, she needed to be nearer the right-hand side of the picture to balance it. The Crop tool was used to do this.

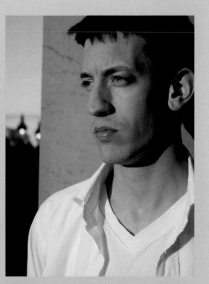

04
This was taken in the golden hour before sunset. The light was coming right across the skyline, and as it was very diffuse, the subject could look in that direction without squinting too much.

02
This image was a little overexposed, so the Curves function was used to darken the shadows.

TOP TIP
Use Exposure Compensation to make images darker or lighter. Negative exposure compensation makes the picture darker, while positive makes it lighter.

TOOLS AT A GLANCE
- IMAGE > ADJUSTMENTS > CURVES
- IMAGE > ADJUSTMENTS > HUE/SATURATION
- CROP

DAYLIGHT ASSIGNMENT: USING WINDOW LIGHT

Window light can be bright and challenging or soft and diffuse. It's the latter case that this assignment concerns. We want you to shoot a head-and-shoulders portrait using window light as the main light source. You are allowed to mix lights if (and only if) the other sources are secondary. The challenge is to produce a thoughtful, atmospheric portrait.

SETTING IT UP

Composition-wise, you can have your subject seated in the window, or back in the room. That's down to your own window/lighting arrangement. In our shots the subject was sitting on the edge of a desk by the window, the camera was 5–6 feet (1.5–2m) away and a 50mm lens was used. The aperture was wide open at f/1.8 and the camera was set to use center-weighted metering, focusing on the bright area of the face.

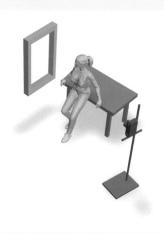

WHY WINDOWS?

While you can use windows where the sun is streaming through, it makes a straightforward portrait very hard, and you may as well be outside. When it is cloudy though or the sun is coming obliquely through net curtains, then the light is much more diffuse so there are no sharp shadows. This allows you to throw the rest of the room into darkness.

TOP TIP

If you find that there isn't quite enough light across the rest of the subject, use a reflector, or improvize and hold up a white sheet, to bounce some light back into the shadow areas.

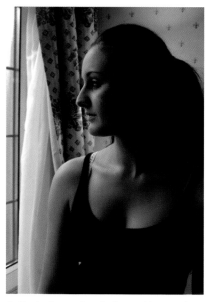

▲ The basic pose here is almost side on to the window. In fact it's angled so that light is cast across the torso, though the other side of the face is dark. Here, there's a lamp behind the model, giving a pleasant yellow glow up the wall, which also defines the head shape as well.

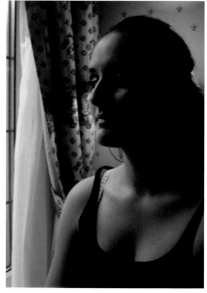

▲ This doesn't quite work, yet is very similar to the first shot. The chin is slightly too far up, too much of the eye nearest the camera is in shadow, and the yellow tends to dominate, not add to the picture. Plus the strap of the top has decided to make a large loop.

BRIGHT IDEA

If the white balance is set for the window light, any lamp light will be yellow. If you set the white balance for the lamp, the window light will be blue. Experiment with the settings for different color combinations.

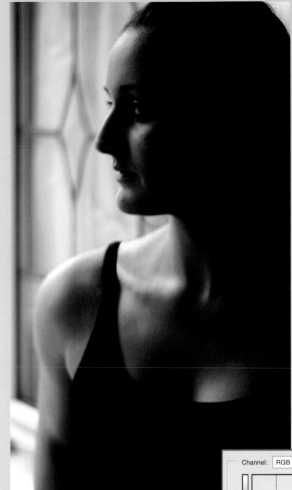

01 This is the image we've gone for. It's a profile shot, but there is just enough light to create variation across the torso, while the lamp light is a subtle addition and the expression is exactly right.

▲ This is an option. The pose is more aggressive, though, with one arm bending away but showing muscle definition, the face pointing downward, and even the angle of the window away from the subject is quite sharp.

02 The tonal spread in the image only used up half of what was available. Levels was used to spread them out and lighten the image.

03 A very shallow S-curve was used to slightly darken the shadows and to lighten the highlights.

TOOLS AT A GLANCE
- IMAGE > ADJUSTMENTS > LEVELS
- IMAGE > ADJUSTMENTS > CURVES

FILL-IN FLASH

One bewildering aspect of photography to beginners is why it is sometimes necessary to use flash outside when it is bright and sunny. Surely you only need flash when it's dark? Well, the answer is of course one of exposure latitude—that is, the ability of the camera to capture a scene from the darkest area to the brightest. Digital cameras can only capture a certain range, so if the background is significantly brighter than your subjects, they will appear in shadow. Or they may be rendered correctly, but the background will be white. Fill-in flash helps to even up the exposure.

FLASH TYPES

If your camera has a built-in flash, then there may be the option for fill-flash, or it could be there is a first-curtain or second-curtain option. The important point is that it is not program-mode flash, which takes into account nothing but illuminating the subject, and does not record the background. On a flashgun you may have the option to set the mode manually, from full brightness to lower settings.

SETTING IT UP

Position your subject so that they are in front of a bright background. Stand around 6 feet (2m) away with a 35–50mm lens setting. Set the flash on your camera to the fill-flash, or equivalent, mode. Put the camera into aperture priority mode and select an aperture like f/2.8. Fire and check the exposure. The subject should be as wellexposed as the background.

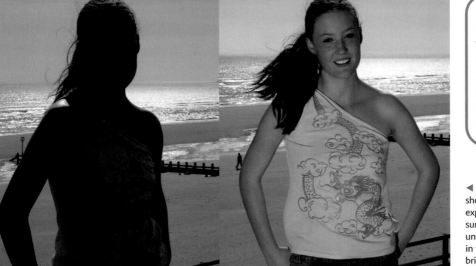

TOP TIP

If you have a problem with red-eye in portraits use the anti-red-eye "strobe" flash, which makes the pupil smaller before the actual flash fires with the shutter.

◄ The picture on the left shows an ordinary zone-metered exposure in bright afternoon sunshine. The subject is completely underexposed. With a flash on, in the picture on the right, the brightness level is brought up to that of the background.

BRIGHT IDEA

Flash systems tend to work differently or offer different features, from camera to flashgun. Get your subject setup, then try out all the settings, making a note of the order you shot them in, to compare the results afterward.

TOP TIP

First-curtain flash is where the camera fires the flash, and then continues on with the exposure so that if the subject moves, there will be a trail after and over the top of the initial image. Second-curtain flash fires at the end of the exposure, so that movement is recorded as a trail with a sharp image at the end.

DIFFERENT STRENGTHS

In some flash systems you can specify the power to be used, relative to the overall exposure. In the picture on the left, the setting is for the flash to be half a stop lower. This brightens it, but leaves much more shadow and depth to the subject. The picture on the right has the flash fully matching the exposure with the background, which makes it bright, but flatter. There's no right or wrong here—it's all down to the look you want.

TOOLS AT A GLANCE
- IMAGE > ADJUSMENTS > LEVELS

STUDIO FLASH AND OPTIONS

The best thing about using electronic flash in the studio compared to natural light on location is that you control where it goes, how strong it is, and, if you don't like it, you can change it. The light from a standard flash head is quite harsh, unless it is diffused by something, which is usually either an umbrella, which normally reflects the light backward, or a softbox, which spreads the light out and gives the softest result.

LIGHTING OPTIONS

There are many accessories for studio lighting that make for greater creative options. Things like colored gels can be placed in front of the flash to give a color to the light. A funnel shape can be added, which is called a snoot, and this directs a tight beam of light that is commonly used to illuminate hair. An attachment called barn doors has four movable flaps that can be used to direct, narrow, or broaden the beam of light. The basic fitting, though, is the softbox or umbrella to diffuse the light and create a more even finish.

METERING STUDIO FLASH

Unlike direct light sources, you cannot use the meter in your camera to calculate the exposure. You have to do it yourself with a light meter. This plugs into the key flash unit, you set the speed on the meter to a typical synchronization speed like $1/125$ sec, and set the mode on the meter to cable flash. Then you connect the meter to the flash unit with a sync lead. The light meter is held up in position in front of the subject, facing the lights. The trigger button is pressed, which activates the lights and gives a reading on the meter. The reading says the power of the lights in terms of aperture. You then dial that aperture setting and the sync speed into your camera, in manual mode, to take the photo.

◀ A single, large softbox provides the light in this shot and is positioned on the right, which is why the left side of the face is darker. You can create perfectly fine and atmospheric pictures with just one light.

◀ Here, the subject is turned toward the main light, called the key light, but on the left now a second light has been added. This is set at a lower power than the one on the right, and so is called a secondary or fill light.

BRIGHT IDEA

It's important to realize that shutter speed has little influence in studio flash work. It is set to a speed that the camera can synchronize with the lights. If there is bright ambient lighting or the subject is moving around quickly, then the speed might be set to 1/250 sec, but most camera/light combinations won't go faster than that.

TOP TIP
The relative strengths of the key light and the fill light are called the lighting ratio. If the fill light is set to be one stop dimmer than the key light, the ratio would be 1:2, as it is half as bright.

▼ This picture uses two, equally powered lights, left and right. This setup is basic and gives an even spread of light throughout the area where the subject is posing. In this case, it means that the face is evenly lit, whereas with one light there would have been significant shadows.

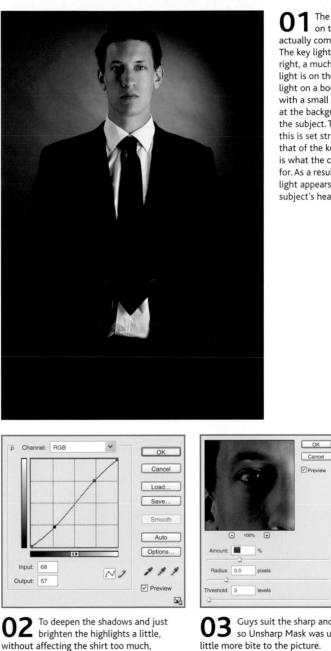

01 The background on this shot is actually completely black. The key light is on the right, a much weaker fill light is on the left, and a light on a boom fitted with a small softbox fires at the background behind the subject. The power of this is set stronger than that of the key light, which is what the camera is set for. As a result, a halo of light appears behind the subject's head.

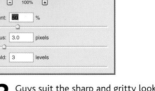

02 To deepen the shadows and just brighten the highlights a little, without affecting the shirt too much, a shallow S-shape Curve was used.

03 Guys suit the sharp and gritty look, so Unsharp Mask was used to add a little more bite to the picture.

TOOLS AT A GLANCE
- IMAGE > ADJUSTMENTS > CURVES
- IMAGE > FILTER > SHARPEN > UNSHARP MASK

STUDIO ASSIGNMENT: SINGLE FLASH

For this assignment, imagine that you are taking a class on photography. Your tutor has set everyone the challenge of producing a portrait, using a 50mm lens, just one flash unit, in a studio with no props. Your task is to come up with the most interesting shot you can.

SETTING IT UP
This is how we set up our shot. The camera is about 8 feet (2.5m) from the subject, with the 50mm lens fitted. We've gone for a black background, because we're dealing with shadows in this shot. The flash has been fitted with a softbox that's in the shape of a letterbox, turned on its end, so that it is tall and narrow. This provides a narrow focused beam of soft light. The model poses so that she is turning away and looking back at the camera.

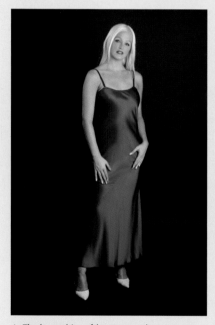

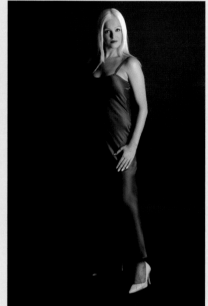

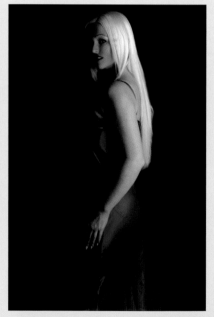

▲ The long, thin softbox means that we can light up the entire length of the model, while not affecting the background to a great degree. However, the pose is a bit bland.

▲ Still on a full-length shot, we're now working the concept of turning away from the light, introducing shadow on the body, and looking back into it.

▲ The length of the shot is shortened to three-quarters and the model is turned right away from the camera. The hair is nicely lit, but the body is almost entirely sideways on.

BRIGHT IDEA
With just one flash unit, you can produce a dark image with bright detail or overexpose the entire thing, and retain a little dark detail. The first is known as a low-key image, the second as a high-key image.

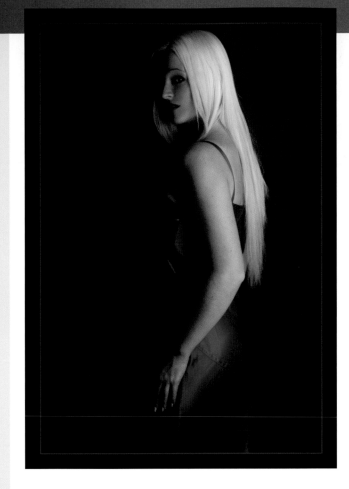

◄ That leads us to this shot. The length is shorter still, but there is more angle on the body, showing more of the back. The hair is still nicely lit and the arm offers shape at the front. The head is turned back to the camera, but half of it is still in shadow. This is our contender.

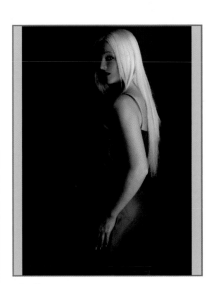

01 The Levels command was used to stretch out the tonal range a little.

02 The shadows were deepened using Curves, while holding the highlights and midtones in position.

03 This is worth looking at because after the image was converted to CMYK for reproduction here, it lost the tonal graduation in the dark areas. To get it back again, a black-white gradient layer on Soft Light blend mode, with a layer mask on the right, was required.

TOOLS AT A GLANCE
- IMAGE > ADJUSTMENTS > LEVELS
- IMAGE > ADJUSTMENTS > CURVES
- CMYK
- GRADIENT LAYER WITH MASK

CREATIVE LIGHTING

Photography is all about using and manipulating the light in the scene, whether that's the natural light, mixed light sources, or the pure environment of the studio. How you use (and particularly combine) lights determines how dramatic, subtle, graphic, or visually pleasing the result is.

SETTING IT UP

This is the setup for the studio shot where two lights were used to give a graphic, *film noir* effect. There is one light on either side of the subject, at 90 degrees to them, so that the lights are pointing sideways. The power was set to f/11 and both softboxes were removed to give harsh light with dark shadows. The camera was about 10 feet (3m) away, using an 18–50mm short telephoto lens. The setting was around 44mm, giving an effective focal range of 66mm on the Fuji S2 digital SLR.

COMBINING LIGHTS

The trick to combining flash and ambient light so that both are recorded faithfully is first of all to meter the background light. Enter that into your camera in manual mode. Then adjust the power on your flashgun so that it produces the correct exposure on the subject. Some flashguns are fairly automatic, so as long as you focus on the subject, the flash will cut off when it thinks there has been enough light.

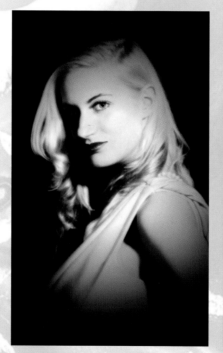

▲ In this shot there is one key light and this has been fitted with a snoot to give a circular, narrow beam of light. To illuminate more area, and to get it to fade out at the edges, it was positioned around 25 feet (7m) back from the subject, giving a spotlight effect. The soft and sepia effects were added in Photoshop.

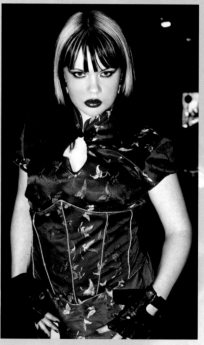

▲ This is a combined ambient and flash-light shot. The window in the background was read with spot metering, then the flash power adjusted to match the metered settings.

BRIGHT IDEA

Experimentation with combining lights and using reflectors or fabrics is the best way to learn how to use them properly. Try firing lights through a patterned, but translucent, fabric to create interesting shadows on the subject.

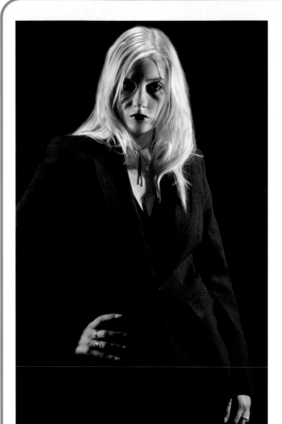

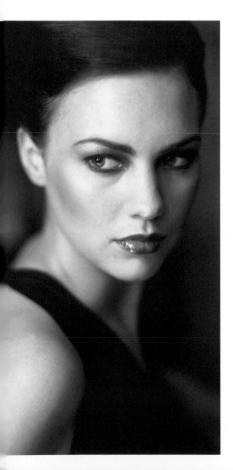

▼ (Below) This "classic" style shot is taken at an ultrafast ISO setting (1600), using a bright, single key-light source, plus a reflector to avoid hard shadows on the face. The image has then had a Film Grain added and been softened using a slight Gaussian blur. Photo: Lizzie Patterson.

01 Using twin flash heads sideways on to the subject produces two panes of light on either side of the face, with a dark ridge in the middle. Hardly flattering, this technique is useful for producing images that require an aspect of menace and *film noir* feel. The shadows across the face can go anywhere because of the messy hair, so a number of shots are usually required.

TOP TIP

When combining ambient and flash light, watch out for the shutter speed. This needs to be at a speed that the flash can synchronize with the camera. For external flashguns, this may be no more than $1/250$ sec, so when metering, set the speed in Shutter Priority mode.

02 The image was brightened a little using a Levels adjustment layer. The hair was masked off to retain the highlights.

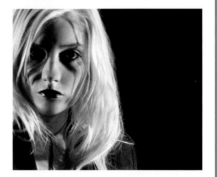

03 The Clone Stamp tool in Darken mode was used to remove some of the flyaway loose hairs that were all over the picture.

TOOLS AT A GLANCE
- LEVELS ADJUSTMENT LAYER
- CLONE STAMP

COMPLEX ASSIGNMENT: PERSONAL PORTRAIT

You have been approached to shoot a portrait for a friend. They want something classy, yet subtle, shot in a traditional studio environment. Your assignment is to shoot this portrait using three lights, yet retain plenty of shadow detail. Anyone can produce a flat picture, covered in light, but you must use the lights to create areas of light and shade.

SETTING IT UP

The task when using more than one light is how to arrange them so that they complement, rather than compete with, each other. The more lights you use, the more difficult it becomes to stop shadows from going in opposite directions. For this shot, the key light is on the right of the camera, set at f/16. There is a fill light on the left, aimed directly into the chest/head area, sideways on. This is set two stops lower at f/8 and provides weak illumination to lighten areas that would otherwise be very dark. The third light is a small softbox on a boom, which hangs over the head and, at f/8, provides subtle lighting for the hair. The lens used is a 50mm prime, with the camera set at f/16.

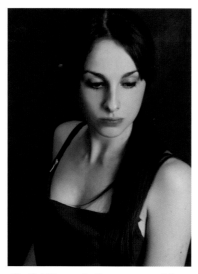

01 This was the first attempt and the lighting works quite well, but the model looks as if she is peering into a bucket.

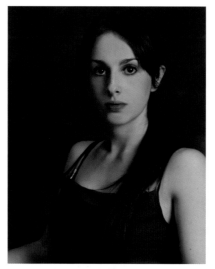

02 Now she's looking back up at the camera, and this shot works well, but we want to see a bit more of her, so the camera goes back a couple of feet. When using a prime lens, you have to move to compose the picture.

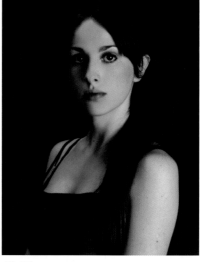

03 We can now see more of the model, and the lighting is very subtle. Note that there is just one catchlight in each eye. This is better than two. The other light doesn't catch because it is too far around to the left.

BRIGHT IDEA

Position a small light behind the subject's head, to one side, and aim it into the hair. You will be able to generate highlights around the side of the hair. Obviously this needs to be done on the side that is the brightest or it may look odd.

03 Being a portrait commission, the subject doesn't want to see bags under the eyes or pimples. The Clone Stamp tool was used at 20% Opacity to smooth all the imperfections out.

04 This has been included just to show you that after conversion to CMYK for printing in this book, the reduced color gamut of CMYK made the picture look dull. The Curves function was used to darken the shadows and provide more contrast. Note that the curve is the opposite way around to one used on RGB images.

01 This is the picture that fits the bill. We've stepped back a little further and placed the model in a nice chair. The hair light is very subtle and could possibly be a little brighter, but the fill light does the job admirably, without creating conflicting shadows, which is what you would have got if it was any brighter. The pose is languid, the overall effect is subtle.

02 The Levels were adjusted so that a fuller range of tones was used and the image became brighter as a result of the midtone marker moving.

TOP TIP
Turn the lights on and off one by one, in turn, while you meter from them. That way you can see what each one is contributing to the overall effect, so that if one area is too bright, you know which light to turn down.

TOOLS AT A GLANCE
- IMAGE > ADJUSTMENTS > LEVELS
- CLONE STAMP
- CMYK
- IMAGE > ADJUSTMENTS > CURVES

TUNGSTEN LIGHTING

The alternative to using electronic flash is tungsten lighting, which is markedly different. There are two types of tungsten lighting—that which goes in domestic light bulbs and lamps, and is weak and creates a significant color cast, and tungsten lamps for photography, which are much brighter, have less of a cast, but put out tremendous amounts of heat. The commercial tungsten lamp comes with a reflecting dish and a tripod, and is similar to flash to set up.

> **TOP TIP**
> When buying a photographic tungsten lamp, ensure that it comes with a cooling fan to extract heat away from the end that faces your models.

COLOR TEMPERATURE

Sunlight has an associated color temperature that varies during the day and under different weather conditions. Electronic flash is calibrated to have a temperature of 5500K, which is the same as average light at midday, giving no color cast. The function of Automatic White Balance on digital cameras is to change the color temperature of the conditions it sees, to that of midday, so that white is rendered with an additional color. Domestic tungsten has a very low color temperature, of around 2000–2500K, which gives a severe red-orange color cast that can be difficult to get rid of later. Photographic tungsten lamps have a higher temperature of 3500K or more, which gives a yellow-orange cast. Provided the WB on the camera is on the right setting, the digital camera can cope with this.

ADVANTAGES OF TUNGSTEN

The advantages for the digital photographer are that tungsten is cheaper than electronic flash, it is a constant light source so you can see where the light and shadows are going to fall, and you can meter it with the camera, rather than a handheld light meter. The disadvantages are that even though it is brighter than domestic tungsten, it's still a little darker than flash, so your subject will have to stay more still. Probably the big issue, though, is that it runs very hot, which in close proximity to the model can make it uncomfortable. The light is also quite harsh, with sharp shadows, unless some form of diffusion is fitted—though care must be exercised that this is suitable, otherwise it will become a fire hazard.

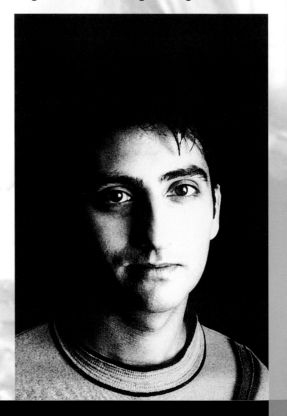

▶ One creative way around the problems of using tungsten is to turn the image into black and white and then tweak the Levels for effect. Photo: Chris Middleton.

BRIGHT IDEA
If you are using a tungsten lamp and the light is not diffuse enough, point it away from the subject, at a large piece of white card that is pointing back onto the set. The light will reflect back in a much more flattering and soft form.

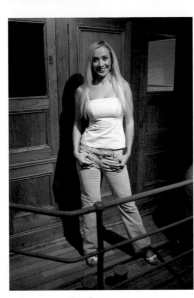

▼ One application of using photographic tungsten is that you can create dramatic shadows with it and, as you can see where the shadows fall, control it quite precisely.

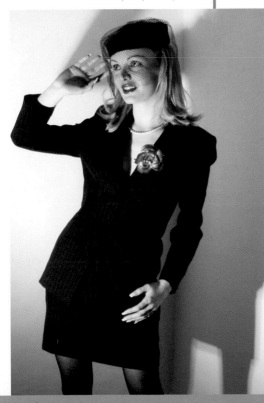

01 Tungsten lighting is likely to be used for interior locations, so you can find yourself shooting under it, like it or not. Remember to set the WB manually though, to counter the color cast, otherwise the result may be like this.

02 The WB has been set to tungsten in this shot, which is why there is little or no color cast and the light on the top looks white.

03 If you forget about this until after shooting, one of the ways of correcting—certainly the easiest—is to use Variations. Ascertain the color cast and then look across to the opposite side of the color selections. This is the tint you will need to add to counter the color cast. Just click on it to add the color and hopefully, remove the cast.

TOOLS AT A GLANCE
- IMAGE > ADJUSTMENTS > VARIATIONS

TUNGSTEN ASSIGNMENT: STAR PORTRAIT

You've been commissioned by someone who is a movie buff to do a portrait of them, rendered in the style of the 1930s stars. You will need a tungsten lamp for the key light and a second light for highlighting the hair. Particular attention must be taken to produce the same kind of lighting effect found in portraits from that time, and the image must be converted to black and white from the digital original.

STYLING AND POSE

The pose should be aloof and aristocratic. Think Marlene Dietrich. No big grins for the camera here. The dress used in this shot is a 1970s reproduction of a 1930s-design dress, made from the same kind of fabric. Add jewelry and scrape the hair back on the head. Add lots of eye liner and mascara—in fact false lashes are recommended.

SETTING IT UP

Position the key light to the right by 45 degrees, and above the model's head, pointing down at 45 degrees. This will give you the characteristic loop lighting signature effect of the day. Position the lamp for the hair anwhere you can so that it adds highlights to the hair. Set the camera 10 feet (3m) away and use nothing less than a 50mm lens. The aperture shouldn't be more than f4 because a shallow depth of field was quite usual.

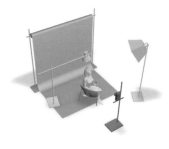

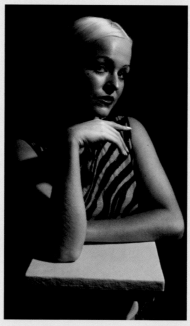

◀ This is from further back and is almost the shot we want. The hand and head poses in particular are spot on, but I checked the focal length and it was 30mm, and really it wouldn't have been shot with such a wide angle. The digital focal-length shift makes the field of view 45mm, which is acceptable, but there is just too much distortion at the front of the picture, with the top of the column and that forearm.

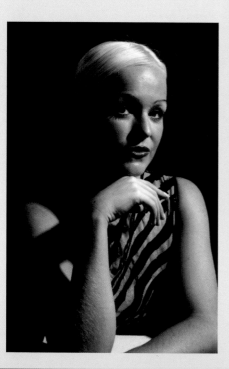

◀ This was one of the early attempts at this assignment, with the model leaning on a Grecian column. It's shown here unretouched, but really it was too close up, with too much forearm.

BRIGHT IDEA

If you haven't got or can't get tungsten lights, use normal flash, but take the softbox or brolley off, so that you get a harsh light with clearly defined shadows.

01 A Levels adjustment layer was used to brighten the image without losing detail in the hair. Note that detail was often lost in the hair in these images, but this was controlled here.

1930S STYLE

So a change of plan, and a chair to sit on. The lighting was set up as described and the expression on the face was one of cool beauty. Usually these shots involved long exposures, so the star had to be able to hold the position comfortably and not move much, hence leaning and sitting shots. However, it doesn't end there, as the studios employed an army of retouchers to make their stars look flawless.

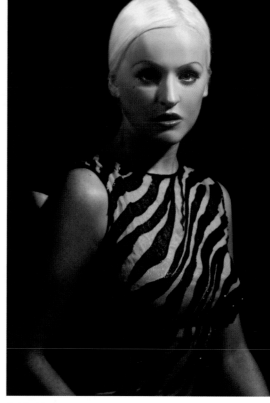

▲ Final image

02 As the image has lots of dark shades, a black-white Gradient Map was applied to turn it into black and white, with lots of dark shadows.

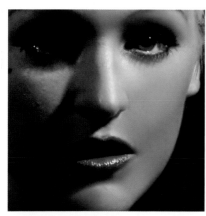

03 A veritable army of people retouched most star portraits, so we're doing the same. The Clone Stamp tool was used at 20% Opacity to smooth everything out.

04 There was too much depth of field in this shot, so the focal points of the image were selected, and the selection was then inverted and a 2-pixel Gaussian Blur was applied.

05 Finally, some grain was added to give the image a little rough texture and feel.

TOOLS AT A GLANCE
- LEVELS ADJUSTMENT LAYER
- IMAGE > ADJUSTMENTS > GRADIENT MAP
- CLONE STAMP
- FILTER > BLUR > GAUSSIAN BLUR
- FILTER > TEXTURE > GRAIN

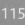

INSPIRATIONS: THE BEST OF LIGHTING STYLES

Whatever form light comes in, whether it's entirely created by the use of electronic flash or tungsten lamps, or it's the sun itself glaring down, how you use it determines the shadows and highlights in a photo. In the studio, it's your job to create the lighting arrangement, while outside, though the light is fixed, you can compose the model and introduce supplementary lighting. Here are four cases, putting that into practice.

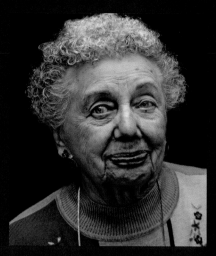

▶ Just because conditions and situations aren't ideal doesn't mean you can't control the environment. Howard Dion shot this image at a Christmas party. To get the textured lighting effect that would throw up all the character in the woman's face, he fired his flash at the ceiling and bounced the light downward.

▶ When you know the rules and the consequences of lighting power, you can break them for creative effect. Kevin Wylie has overexposed this scene where a model is standing in front of a mirror. Flash has obliterated all but the key details of her face and body in the reflection, and the partial element of the back of her head.

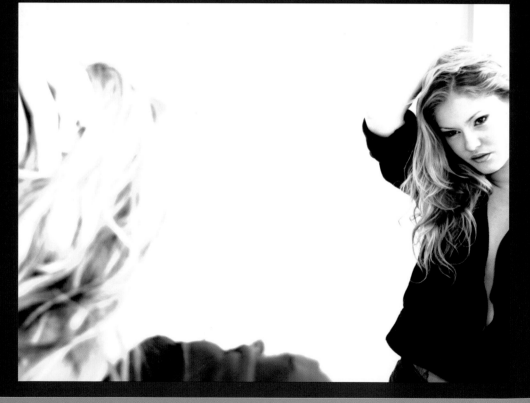

◀ Andrew Maidanik shot this image for his stylist, who wanted a very glamorous look for her own portfolio. In the studio he used two flash heads with softboxes. A large one was set at 45 degrees in front and a small one was used as a hair light by being placed above and behind at 45 degrees opposite the large one.

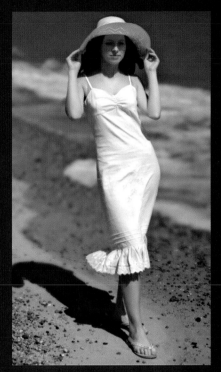

▲ The early afternoon sun is bright and harsh, and not very good for portraits. That doesn't mean you can't shoot and make use of it, though. Here the subject is brightly lit in the sunshine, strolling along the beach, with her eyes protected from the glare by a large sun hat.

TOP TIP

Throw light into dark corners or where shadows are oppressive through the use of a reflector. It's like having an extra light, but it can be used in the studio and taken to any location.

117

6 IMAGE EDITING

Digital photography is intimately tied to computers and photo editing. It starts as a digital file and is easily transferred to computer for enhancement, correction, and the creation of totally different images. The computer is then the equivalent of the old darkroom of chemicals, but besides improving pictures in ways not possible chemically, it can give full rein to your creativity, allowing manipulation and image creation that know no limits.

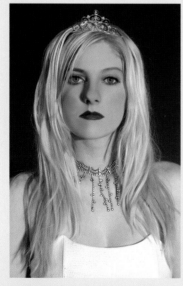

▲ No-one can look great every day— remove those blemishes, tidy up tired eyes, and make your subject look fresh and perfect.

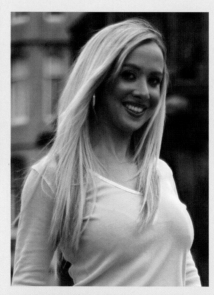

▲ Automatic White Balance is a great and desirable thing, but sometimes it gets things wrong and the result is a color cast. Here's how to adjust and correct colors in an image.

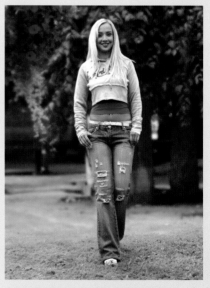

▲ Depth of field is a fickle beast. If you don't keep an eye on it, too much sharpness may make the background of your photo a distraction. Here's the clever way to knock it back.

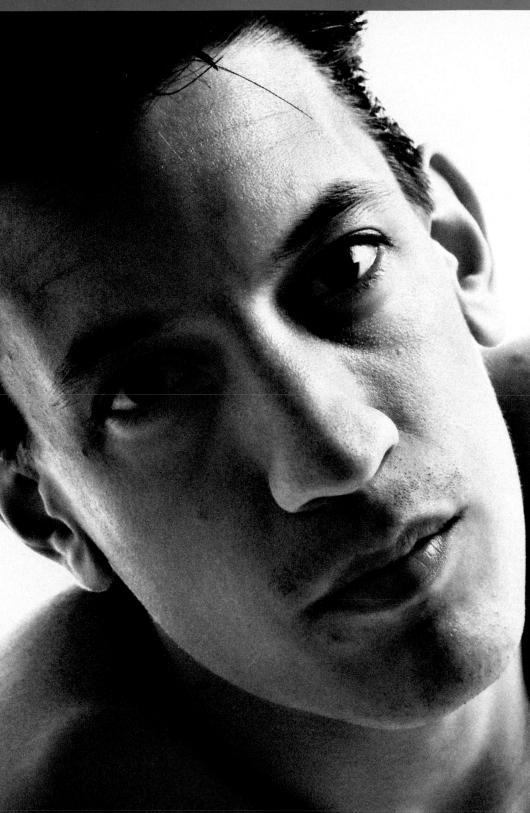

▼ You shoot color with digital, but on the computer it can be anything you like, including black and white. Turn it into a punchy, high-contrast monochrome image.

119

RETOUCHING AND PERFECTING

When you photograph people, you never know how they will look. Some people can look the part with the minimum of effort, but others look as if they've been dragged through a hedge. Fortunately, digital editing can come to the rescue, and while it's preferable not to have to do this at all, don't despair if your subject does look worse for wear—it can be fixed.

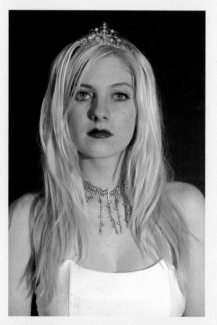

▲ This is the original image and the model looks a little tired, the lipstick is all over the place, and there are one or two moles and blemishes that need to be erased.

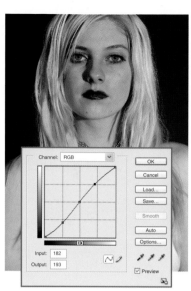

01 The first thing to do is ensure the color and contrast are as you want them. In this case, that background isn't very black, so use Curves to increase the contrast. Then zoom in to 100%.

02 To get rid of the moles and most of the blemishes in one easy fashion, select the Clone Stamp tool. Set the Opacity at 100% and the Blend mode to Lighten. Now, sample from close by the mole/blemish, where the skin tone is the same brightness as that surrounding the blemish. One click should do the trick.

03 Now create a duplicate layer in the Layers palette. If the next stage goes wrong, you need to be able ditch it without losing the adjustments made so far. Rename it as Working layer, just so that it's obvious.

04 Select the Clone Stamp tool again. Now move up to the face and set the brush size so that it fits easily between the top of the lip and the nose. Set the Hardness to 50%. This gives a harder edge to the brush. Ensure the Opacity is on 100% and the Blend mode is Lighten. Sample from above the lip and paint down onto the edge of the lip, so that the smudgy lipstick is cleaned up.

TOP TIP

Using the Clone tool at 100% Opacity retains the sharpness and texture in the area you are cloning over. Reducing makes it softer and smoother.

BRIGHT IDEA
If your subject has a few too many wrinkles, go for the soft focus look. Create a duplicate layer and apply a Gaussian Blur to it. Then add a layer mask and mask off the eyes and lips so that they appear sharper.

05 You might get some repeated textures, but not to worry at this point. Now reduce the brush size, set the Blend mode to Darken, and fill in any gaps of lipstick where there should be war paint. It's worth zooming in further to do this.

06 Zoom back out to 100%. Increase the brush size, and set the Hardness at 0%. Set the Blend mode to Normal and reduce the Opacity to 20%. Now, sample from the cheekbones, and carefully paint under the eyes to remove eyebags. Change the sample point for a second sweep. Don't overdo it, to ensure there is some texture there.

07 Now move out to the rest of the face. Start by smoothing out the cheek area, then clone that out into the nose and down onto the area above the lip. Work the chin area up to the lips and the jawline out to both other areas. It's important to work the areas, then merge them together, rather than clone in one motion, as the shading tends to be different in each area.

08 Keep zooming back out to see the overall progress and that the shading across the face is working. Then move up to the forehead and repeat the same process. If the subject has dark eyebrows and they need a "lift," use the Burn tool to enhance them. Also, use the Burn tool to add definition to the cheekbones. When you are happy, merge the layers.

TOOLS AT A GLANCE
- IMAGE > ADJUSTMENTS > CURVES
- DUPLICATE LAYER
- CLONE STAMP
- BURN TOOL

CORRECTING COLORS

Colors can go wrong in a digital image for a number of reasons. It can be as simple as shooting a scene where two colors clash, or the subject and the backdrop are the same color. The most common cause for having to correct colors in a digital image is down to the white balance, particularly when it is left on Automatic. Bright, white skies can produce a blue cast, especially in the morning if there is no sun, while late evenings can introduce reddish tints. Tungsten can throw in some yellow coloring as well.

▼ One minute it was sunny, and so the white balance had been manually set for that, the next it had clouded over, but I forgot to change the setting, resulting in this blue cast to the image.

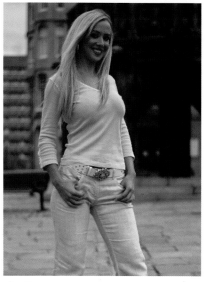

01 The immediate problem of correcting this image should be apparent—the color cast is the same color as the outfit the girl is wearing. The simplest thing to try first is to go to Variations and add yellow to the image. Already the outfit is starting to look paler than it should.

02 The next thing to try is to go to Image > Adjustments > Auto Color. Select this and you will see it make a fair job of correcting the color. The background in fact is perfectly fine now. This is an acceptable result.

03 A more complex alternative is to go to the Layers palette and select a Color Balance Adjustment layer. Now adjust the colors, taking out the Blue and putting in lots of Yellow. You can also shift toward Red as well, so that it keeps a healthy, warm feel to the picture. This is more accurate because you can fine-tune the result. Click OK.

BRIGHT IDEA
Be creative with the color controls and produce heavily tinted versions of the same image, in an Andy Warhol style.

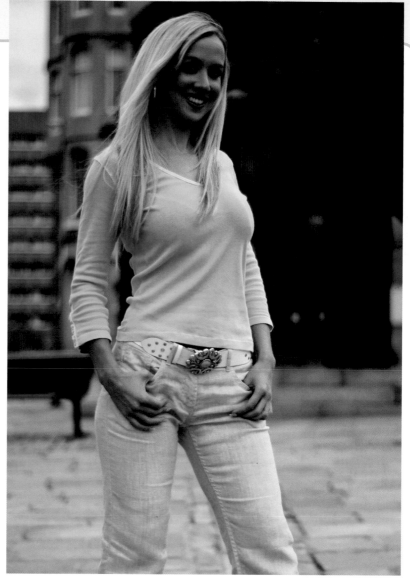

04
Now select the Paintbrush, with black as the foreground color, and set the Opacity at 25%. Paint carefully onto the blue clothing, to put back some of the blue that has been taken out through the color balance adjustment. You can now merge the layers.

05
To put some strength back into the cyan color you can use Hue/Adjustment and select Cyans and use the color picker to select it, or go to Image > Adjustments > Selective Color. Select Cyans as the color and increase the Black by 20%. This makes the color a little deeper.

06
Once you've checked the background again and made any final adjustments, save the image, free from that awful color cast.

TOP TIP
There are a number of different ways of changing colors, so try to choose the one that corrects the colors that are wrong, without affecting the colors that are right.

TOOLS AT A GLANCE
- IMAGE > ADJUSTMENTS > VARIATIONS
- IMAGE > ADJUSTMENTS > AUTO COLOR
- COLOR BALANCE ADJUSTMENT LAYER
- IMAGE > ADJUSTMENTS > HUE/SATURATION
- IMAGE > ADJUSTMENTS > SELECTIVE COLOR

KNOCKING OUT BACKGROUNDS

One of the tricks of portrait photography is to render the background out of focus, so that the viewer can concentrate on the figure, with the backdrop providing a pleasing combination of colors and diffuse shapes. Where a narrow aperture has been used, too much depth of field is present, leading to backgrounds that compete with the subject. Compact digital cameras suffer from this much more than digital SLRs because of the size of the sensor and lens. The solution is to knock out the background, but to do it so that it looks realistic.

▼ This is the original picture, and while it's not awful, the flowers dangling in the foreground are intrusive and the subject hasn't been separated from the background enough.

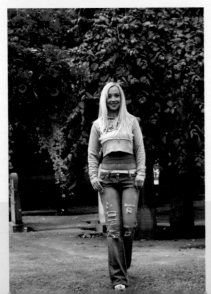

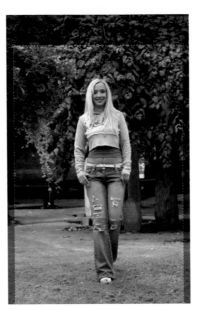

01 The first rule of photo editing is not to make work for yourself. So crop the picture, getting rid of wasted space above the subject's head.

02 Ensure that any tweaks have been completed, then click on the Quick Mask icon in the Tools palette. Ensure the Brush Opacity is set to 100% and paint the foreground, and up through the middle of the subject.

03 Zoom in, reduce the brush size to make it smaller, and set the Hardness to 65% so that the brush has a harder edge. Now paint up to the edge of the subject, all the way around.

04 Set the brush Hardness back to 0%, the Opacity to 25%, and increase the size. Now paint around the feet area and sideways across the image where the border is between the masked area and the clear area. The idea is to blend it in.

BRIGHT IDEA
Save the work as you go along, as a Photoshop file so that all the layers are retained. If you make a mistake, you can easily go back through the history palette and retry a stage.

05 Once completed, click on the Standard mode icon to come out of Quick Mask mode. A selection will appear. Go to Select and click on Inverse. Copy this selected area and paste it as a new layer. The reason for doing this is that a Gaussian Blur will be applied to the background, and even if the figure is masked off, the routine will pull in elements under the boundary of the selection, creating a halo effect.

06 Now select the background layer and then the Clone Stamp tool. Set the Opacity to 100% and go around the edges of the figure, cloning grass in. It only needs to go in a little and there's no need for any accuracy, it's simply to stop the halo effect. To make it easier to see, turn off visibility to the figure layer.

07 Create a duplicate of this layer and call it Blur layer. Now go to Filter > Blur > Gaussian Blur and enter a strength of 10 pixels. Then click on the Add Mask icon in the Layers palette. Set the Opacity of the Paintbrush to 25% and the color to black. Now paint over areas that should be slightly sharper than the very back of the picture. In this case, the flowers in the top left and the trees and leaves in the midground. Merge the layers.

TOP TIP

To quickly erase mistakes while applying the mask, switch from black to white foreground color and paint over the affected area. Then switch back again.

08 The final image now has a much more attractive and diffuse background, with slightly different levels of detail, and no Gaussian Blur halo around the figure.

▟ **TOOLS AT A GLANCE**
- CROP - FILTER > BLUR > GAUSSIAN BLUR
- QUICK MASK - LAYER MASK
- CLONE STAMP

PUNCHY BLACK AND WHITE

Black and white photography is largely about tones, tonal range, textures, and lighting. However, when you push it to the extremes, reduce the midtones and concentrate on light and dark, you get high-contrast images that really leap off the page. In digital, you can decide whether to go for a wide range or to concentrate on creating a punchy image, possibly adding film grain for an authentic feel.

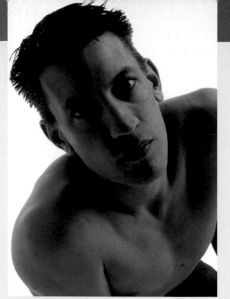

▶ This is the original image in color, with creative lighting and a dynamic pose and camera slant.

SETTING IT UP

The subject is posed against a white background, which is lit by two flash units, set to a higher power than the key light. The key light is to the right of the subject, while a secondary, fill light is to the left. The objective is to produce areas of light and shadow. Then, take the subject and get them to adopt a more aggressive or deliberate posture than normal and angle the camera for a dynamic slant. Stand about 6–10 feet (2–3m) back and zoom in with a short telephoto lens to fill the frame.

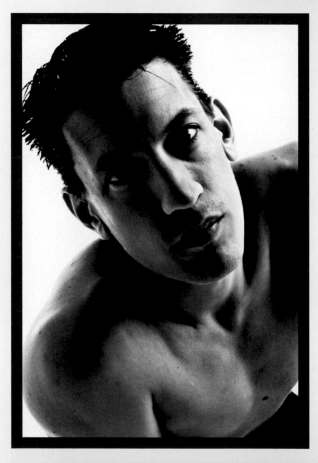

◀ The completed image uses lots of contrast as well as grain and a strong, black border to hold it all in.

BRIGHT IDEA

Don't shoot using the black and white mode on your camera if it has one. It's always better to shoot in color, because then you can convert to black and white with more control. It also leaves you with a color version to use as well.

TOP TIP

You need to think in terms of contrasts, not in terms of color. If you are finding it hard, switch the camera temporarily to black and white mode and look at the scene on the LCD. Then, having composed and lit it appropriately, switch back to color mode to shoot.

CONVERSION OPTIONS

The two best methods of converting to black and white from a color digital image are either to use a Gradient Map adjustment layer, with a black–white gradient, or to use the Channel Mixer.

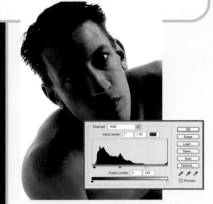

01 First of all, use the Levels control to ensure that the full range of tones is being utilized. Pull in the slider on the right so that those high tones, which represent the background, are turned into pure white.

02 Now go to Image> Adjustments> Channel Mixer and put a tick in the Monochrome box. Set the Red channel, which represents the skin tones, to 50%, the Blue and Green channels to 25% each.

03 Go to the Layers palette and select a Curves adjustment layer. Enter a classic S-shape curve, which darkens the shadows and brightens the highlights.

04 Select black as the foreground color and then the Paintbrush. Set the Opacity to 20% and paint over highlights around the nose that are blown out, and in the corner of the eye on the left that is too dark.

05 Merge these layers then go to Filter> Sharpen> Unsharp Mask. Enter values of Amount: 50%, Radius: 50 pixels and Threshold: 3. This will make the image much more contrasty and punchy. Crop out any wasted space.

06 This next stage is optional. Create a duplicate layer and set the layer Blend mode to Luminosity. Go to Filter> Texture> Grain. Set the Intensity to 30 and the Contrast to 50. This adds colored grain, but the Blend mode ensures it is only added in black and white. Merge, and save.

TOOLS AT A GLANCE
ADJUSTMENTS > LEVELS
- IMAGE > ADJUSTMENTS > CHANNEL MIXER
- CURVES ADJUSTMENT LAYER

- FILTER > SHARPEN > UNSHARP MASK
- FILTER > TEXTURE > GRAIN

7 STORE, PRINT, PUBLISH

Capturing the image and tweaking it is only half the digital story. You then have to determine file formats, storage, how to archive and back up your precious photos. Then there's the not-so-simple matter of printing them and the various options for use on the internet, personal Web space, e-mail, and finally, creating a slideshow on DVD so there's no reason for relatives to avoid your digital vacation photos.

STORAGE AND FILE FORMATS

In the old days, the photo you shot was recorded onto film, but with digital the picture is developed in the camera, and then it needs to be stored somewhere. Initially this is onto a memory card, and from there it usually ends up on your computer, but it can also be archived onto other formats. And then you start looking at file formats, file sizes, compression artefacts, and the simple suddenly becomes a little bit more complicated.

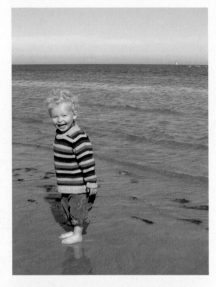

IN THE CAMERA

You can start making a choice over file formats right at the start, when you are shooting with the camera. There is usually the choice of saving the pictures in RAW, TIFF, or JPEG format. The advantage of RAW is that pictures take up less space than TIFFs and can often be adjusted in proprietary software issued by the camera manufacturer. Some commercial software also offers the ability to read a variety of RAW formats. Usually, though, you'll need to convert the RAW image to TIFF or JPEG on your computer, so it can introduce an extra stage in the imaging process.

TIFF, or Tagged Image File Format, is an uncompressed format, so that the quality of the file is preserved perfectly. However, it takes up the most space, and even on a 512Mb memory card, you are only going to get 30 pictures from a 6Mp camera. However, if shooting landscapes, where every pixel of detail is important, TIFFs are recommended.

JPEG stands for Joint Photographic Experts Group, and is a compressable file format, where the user can dictate the level of compression. In real terms there are usually three or four settings on the camera, from minimal or no compression to significant compression. The more compression, the smaller the resulting file size and the more pictures you can store on a card—but, and it's a big but—the more the picture quality is degraded. For shooting portraits, if you set the file quality to maximum, and the compression to minimal or none, then you can shoot portraits using JPEGs without any problem. Instead of 30 pictures, you're suddenly looking at 170-200 on that same 512Mb card.

◀ It's okay to shoot portraits as high-quality JPEGS, but after editing they must be saved as TIFFs to avoid the image quality degrading.

▶ DVD-burning software normally comes with the burner drive, and allows you to easily copy and back up your vital photos.

ON THE COMPUTER

Once pictures have been copied to your computer and you are working or tweaking them, you are strongly advised to save them as TIFF files, regardless of the format they were captured in. The reason for this is that resaving JPEG files, even at maximum quality, means the file is recompressed, instantly degrading the image quality.

There are plenty of other file formats, though none is more useful for general photographic images. When you want to put images online, then GIFs and their successor, the PNG format, come into the question. See pages 134–135 for using images on the Web.

ARCHIVING

So, you have your massive collection of 17Mb TIFF files clogging up the hard drive, and they will soon eat up all the available space. But suppose the hard drive fails?

Storing photographic files on CD isn't much of an option. Okay, if you've got a pile of JPEG files that have never been tweaked or resaved, then yes, you can get around 280 pictures on one CD. If you've been saving them as TIFFs, on the other hand, then you will get around 40 on a disk. That's hardly worth the effort. The question of whether to use a CD-R, which can be used multiple times, but whose files cannot be erased, or a CD-RW, which does allow files to be removed, thus becomes a moot one.

The solution then is to save your hi-res photographic files on to DVD. There are two main formats, DVD-R and DVD+R, plus two accompanying rewriteable formats. Currently, the DVD-R make is a little more popular, though any sub-$50 DVD burner will do both formats. On a single-sided, 4.7Gb DVD disk, you can look forward to storing around 1880 JPEG files and 276 TIFFs.

Things will improve when "Blu-Ray" and HD-DVD disks become standard, which may offer capacities of 25–50GB, or more—but you will need new hardware!

▲ CDs are good for storing JPEGs fresh out of the camera, as backups, but when you want to archive TIFFs it's better to turn to DVDs.

 ESSENTIAL ITEMS
- DVD BURNER
- MEMORY CARDS

THE PRINTED IMAGE

Color management and printing are a whole book by themselves, but essentially it is the process of trying to match what you see onscreen with what you get on paper when it's printed. The problems start when you realize that the screen is an RGB, light-emitting device, and that printing is a CMYK, light-reflective process. On those grounds alone, the two will never appear exactly the same. The challenge, though, is to make them as close as possible.

▼ The Epson Stylus PHOTO 1290 S, a widely used printer with excellent printing abilities.

WHAT IS RGB?

Let's start with this. RGB stands for Red, Green, Blue and is an additive system of color generation that is used by digital cameras, phones, monitors, and televisions. It has three component channels of color, which mix together to form the final color. Where the three channels are the same value, the result is a shade of gray. Where all three are zero, the result is black, and when all three are 255, the result is white. However, there are many more colors available than the system can represent, which is where color profiles come in. These represent spreads of color throughout the spectrum. The two most common are sRGB and AdobeRGB. They have exactly the same number of different colors each, but the spectrum, or gamut, that AdobeRGB covers is wider. If you are shooting, or want to create, images with bright colors, then it is a better profile to use and print with. However, if the image does not have very bright colors, then sRGB will give you finer graduations of color, because its colors are closer together in the spectrum.

WHAT IS CMYK?

Cyan, Magenta, Yellow, and black (or Key) is a physical ink system of creating when printing. Images that are destined for commercial print processes, like all the images in this book, will need to be converted from RGB to CMYK first. The trouble with CMYK is that it has a much narrower color gamut than any RGB profile. It is particularly bad at bright colors, such as red and orange. To make matters worse, the results you get from CMYK are dependent upon the actual, physical printing press being used. For color-critical work, professionals will request a color profile from the printing lab so that the image can be prepared fully. For the average photo user, who is seeing work heading off to a commercial process, it's a case of converting the image to CMYK yourself, and ensuring that the color representation is satisfactory.

BRIGHT IDEA
Can't afford a hardware device to calibrate your screen with the output? Photoshop comes with something called Adobe Gamma. This can be used to perform basic color calibration on the monitor, which can be set up to use the same color profile that your software is using.

TOP TIP
After converting from RGB to CMYK, color tends to be flatter. Use Brightness/Contrast to increase the Contrast by up to 10% to compensate.

COLOR CALIBRATION

The best way to ensure color output from the screen comes close to what is on paper is to use a screen calibration system. This is a hardware device that scans the colors and brightness being emitted, and checks it against the output. However, for total accuracy, you will need profiles for each type of paper that you print out on. Also, it's worth bearing in mind, that not all photo printers are the same. Some are considerably better than others. If you are serious about printing your own photos, then investing in a good-quality printer with a minimum of six separate ink cartridges is required. The more ink tanks there are, the more variety of color can be reproduced, and the cheaper it is to run because only the empty tanks need to be replaced at any one time.

▲ If you go to Image Resolution in Photoshop and remove the tick from Resample Image, then set the Resolution at 300dpi, you can see how big the picture will print at.

▼ More practically, if you actually enter the size you want to print it, you can see the Resolution (the print density) of this 6Mp image is 177dpi. That's fine for printing an image at A3 so the printing can go ahead.

PRINTING RESOLUTION

Oh, the pain of printer resolutions! This is an area that never fails to confuse anyone new to the joys of home printing. The very first thing that needs to be understood is that the printing dots per inch (or dpi) is not image resolution; it is something you set to determine how densely packed the dots are in the image when it is printed. The minimum dpi that should be used is 150dpi, and this is normally when you are printing A3 images. The maximum that is worth setting is 300dpi, which is the print density used in commercial printing.

When setting the print density for home printing, what you are really setting first and foremost is how large you want to print the image. Set this in terms of the image fitting on the paper, then check to see what dpi will be the result. Between 150 and 300dpi, and you're okay. What you don't do is set the dpi to 300 and then print the image. The size it will be printed at will be dependent upon the pixel size of the image. The chart below will give you some clues to how large you can print images and what the image resolution will need to be.

Print size	Minimum 150dpi	Ideal 300dpi
6" x 4" (15 x 10cm)	900x600 pixels	1800x1200 pixels
8" x 6" (20 x 15cm)	1200x900 pixels	2100x1500 pixels
A4	1754x1240 pixels	3508x2480 pixels
A3	2480x1754 pixels	4960x3508 pixels

CONCEPTS
- sRGB
- AdobeRGB
- CMYK
- CALIBRATION
- PRINT DENSITY

WEB USE AND E-MAIL

It's inevitable that digital photos will be used on the Web and sent to friends and relatives by e-mail. However, even if you do have a superfast internet connection, your recipient might not, and more importantly they probably have a limit on their mailbox for how much can be sent to them. That means that those 17Mb TIFFs are not really suitable for transmission, or using on a Web site, where speed of access is paramount.

ON THE WEB

Posting images to online competitions, or to your own Web space, is a good way to get your photography seen by the masses. Usually, other people's Web sites will have a maximum picture size and a maximum file size for submissions, so that if your image goes over that, it will be rejected by the server. The standard format for submission is JPEG, using a modest level of compression. While you can use formats such as PNG for your own Web site, these are normally used for graphics and animated menus and maps, rather than photos.

If you know the limits that you are aiming for, then it's a simple matter to go to Image > Image Size and enter the new dimensions. However, to get under the file size limit, you must also set the compression high enough.

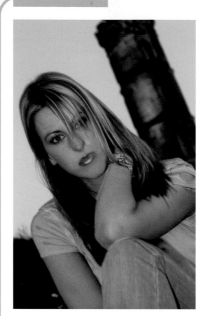

01 I want to use this image on a server, but the requirements are that no side shall be longer than 700 pixels and the file size must be below 100K. Firstly, Image Size is used to reduce the size.

02 The process of reducing file size also makes an image softer, therefore it might need to be sharpened. Unsharp Mask is used. Lower settings than normal are applied because the resolution is so much lower.

03 Now go to File > Save As and select JPEG and a file name. On the next screen you get to set the compression and the resulting file size. Bear in mind that the actual size on the hard drive will probably be 10% more than what you are told, so this, at 82K, should fit in easily. A compression factor of nine isn't so severe that it will damage the small image, either.

> **TOP TIP**
> Don't use JPEG compression lower than 6/12 in Photoshop as the picture will start to develop JPEG artifacts, damaging it.

BRIGHT IDEA
There are plenty of photo sites where you can enter pictures for rating and critique by your peers. Try www.photonet.com as this is one of the largest in the world.

E-MAILING PICTURES

As explained opposite, it isn't so much a matter of how fast you can send images, but how fast the person at the other end can download them from their mail server, and what size limits their mailbox has. For example, many mail servers will reject an attachment greater than 10Mb. Even if you are sending JPEGs, it means that either they have to have a good deal of compression, or you need to reduce the size. Do your relatives really need to see the 3024 x 2016 original-size image? No, of course not, so 1200 x 800 is not only plenty for viewing onscreen, it means that they can print the picture up to 7"x5" (18 x 13cm) if they want to as well. If you need to send quite a few images, then 640 x 480 is fine for onscreen viewing, though not for any other use.

DIGITAL OUTPUT

There's more you can do with your pictures besides printing and uploading them. How about creating a slideshow on DVD? Just because you don't have an album of pictures any more, there's no reason for people to escape your vacation photos. There are specific programs designed to create a DVD menu and resize the pictures so that they are the correct orientation and a suitable size for displaying on a TV. You can add your favorite music, captions, and text to explain where it is you were and what the picture shows. It's worth looking into the features of the software that comes with your DVD writer because the facility to create slideshows is often included.

PDF PRESENTATION

The Portable Document Format was designed by Adobe to allow documents with illustrations and pictures to be edited, shared, and commented on. It's a more professional application and is largely there as a more accessible format to the traditional PowerPoint presentation. Digital photos can be used in this, and Photoshop comes with a built-in batch process action, designed to run pictures together, complete with transitions. You can then save and distribute it as an example of your work. Photoshop also has the option to create a Picture Package, where a selection of photos can be displayed together.

▲ Creating a slideshow to run automatically from a DVD is easy, and there are a number of inexpensive programs that will do the job.

▼ Create a PDF presentation, then distribute the file to show your work.

8 APPENDIX

We hope that this Digital Photography Workshop has been useful and inspirational, revealing the process and creative thinking behind some eye-catching portraits. Now read on for a technical glossary, index, and a guide to our featured photographers.

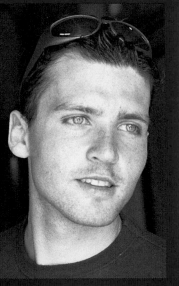 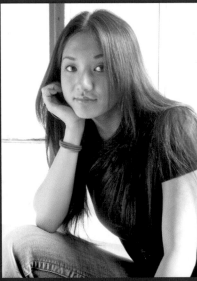 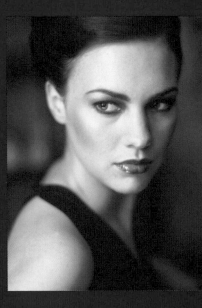

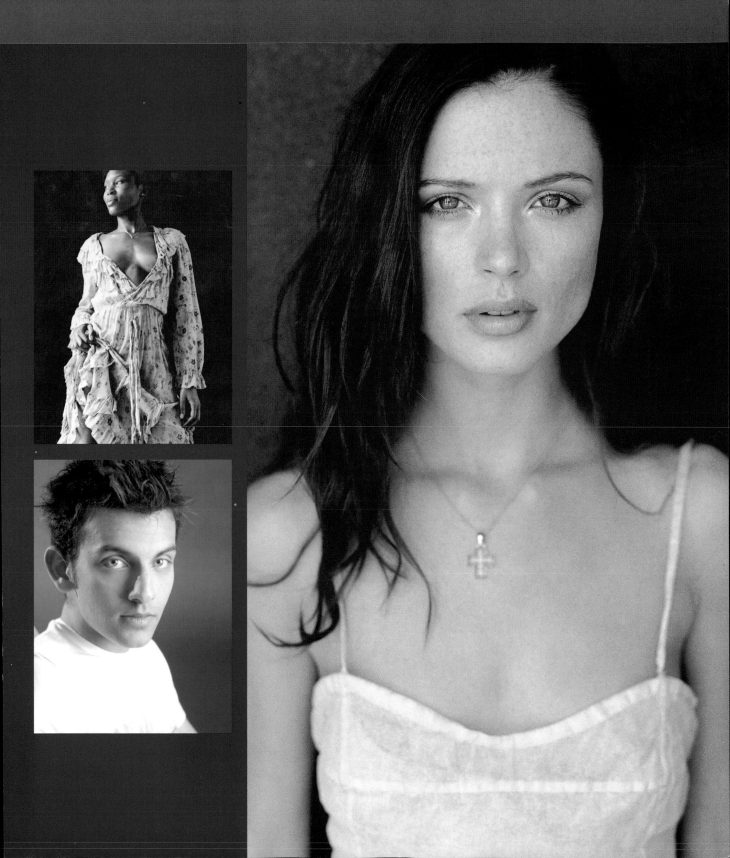

GLOSSARY

AdobeRGB 1998: Color profile based on the RGB system with a wide color gamut suitable for photographic images. See also sRGB.

AEL (Automatic Exposure Lock): A camera option to lock the setting of the exposure once read, so that the camera can be moved and the scene recomposed, without it being metered again, and giving a different result.

AF Illuminator: When the light isn't bright enough to allow the autofocus to detect a contrast difference, a spotting light, or infrared light, comes on to light up the target area and make it possible.

Aperture: The opening to a camera's lens that allows light into the camera to strike the CCD. See also f-stop.

Aperture priority: Camera shooting mode. It allows the user to set the camera's aperture (f-stop) while the camera calculates the optimum exposure time.

Artifact: Minor damage or fault on a photograph, usually caused by JPEG file compression.

Automatic white balance: The system within a digital camera that removes color casts in images caused by the hues of different types of light.

Bit (binary digit): The smallest unit of information used by computers.

Bitmap: A digital image made of a grid of color or grayscale pixels.

Byte: A string of eight bits. 1024 bytes make a kilobyte (KB), and 1024KB make a megabyte (MB).

CCD (Charge Coupled Device): An electronic device that captures light waves and converts them into electrical signals.

CD-R: A compact disk that data can be written to but not erased from.

CD-RW: A compact disk that can be erased and used a number of times.

Chromatic aberration: Colors bordering backlit objects, caused by the poor-quality lens systems used in many compact cameras. Can also affect high-quality optical systems, but only to a limited degree.

CMOS (Complementary Metal Oxide Semiconductor): A light-sensitive chip used in some digital cameras and scanners instead of CCDs. CMOS chips are cheaper to develop and manufacture than CCD chips, but they tend to produce softer images.

CMYK (Cyan, Magenta, Yellow, Key [Black]): The secondary colors from which other colors can be derived. CMYK is used to reproduce colors on the printed page and has a narrower gamut than RGB. See also RGB.

CompactFlash: A type of memory card with the interface built in.

Compression: A process that reduces a file's size. Lossy compression systems reduce the quality of the file. Lossless compression does not damage an image. See also JPEG.

Digital image: A picture made up of pixels and recorded as data.

Digital zoom: A process that simulates the effect of a zoom by cropping photos and enlarging the remaining image. It reduces image size. See also Interpolation and Zoom lens.

Download: The process of transferring data from one source to another, typically from a camera to a computer.

dpi (dots per inch): A measurement of print density that defines the image size when printed, not its resolution.

DVD (Digital Video/Versatile Disk): A high capacity storage medium like a CD, but offering six times the space.

DVD-R: The most common type of recordable DVD disk. While it is multisession-compatible, data cannot be erased from it.

DVD-RW and DVD+RW: Eraseable and re-recordable versions of DVD.

Dynamic range: The range of the lightest to the darkest areas in a scene that a CCD can distinguish. Also known as exposure latitude.

Electronic viewfinder: A small LCD display that replaces optical viewfinders in some digital cameras.

EXIF (Exchangeable Image File): Shooting data recorded along with the picture by a digital camera.

Exposure compensation: An adjustment applied to a photograph to correct exposure, without adjusting the aperture or shutter speed.

Exposure value (EV): The measurement of a photograph's brightness.

f-stop: A camera's aperture setting. A high f-stop number means the camera is using a narrow aperture.

File size: A file's size is determined by the amount of data it contains.

GIF (Graphic Interchange File): Common internet graphic format, used for banners and icons where few colors are required.

Guide Number (GN): Measurement of the range or power of a flashgun. To manually work out what camera aperture to set, divide the guide number by the distance to the object. This gives the f-stop to use. However, most flashguns also have sensors that cut the flash off when they think the exposure is correct, so the GN is more commonly used to define power.

Image-editing software: The program used to manipulate digital images. Also known as image-processing, image-manipulation, photo-editing or imaging software.

Image resolution: The number of pixels stored in a digital image.

Ink-jet printer: A printer that sprays fine dots of ink on to paper to produce prints.

Interpolation: A process to increase an image's resolution by adding new pixels. This can reduce image quality.

JPEG or JPG (Joint Photographic Experts Group: A file format that reduces a digital image's file size at the expense of image quality.

k/s (kilobyte per second): kilobyte per second. A measurement of data transfer rates.

Kelvin: The measurement used to classify color temperature. Daylight at midday is rated at 5500K.

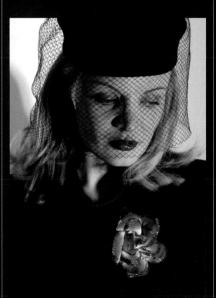

Kilobyte (k or KB): A unit of computer memory equal to 1024 bytes.

LAB color: A color mode consisting of a Lightness channel and two color channels, A (covering green to red), and B (covering blue to yellow colors).

Laser printer: A printer that print fuses toner or carbon powder on to the paper surface.

LCD (Liquid Crystal Display): A small light display, lit by running a current through an electrically reactive substance held between two electrodes.

LCD monitor: A small, color display built into most digital cameras. Allows the user to preview/review digital photos as they are taken.

Lithium-ion (or Li-ion): Powerful rechargeable batteries, not affected by the memory effect. See also Ni-Cd.

MAh (Milliamp hours): A unit of measure to describe a battery's power capacity.

Mb/s (megabyte per second): A measurement of data transfer rates.

Megabyte (Mb or MB): A unit of computer memory, equal to 1024 kilobytes.

Megapixel (Mp): One million pixels. A standard term of reference for digital cameras. It multiplies the maximum horizontal and vertical resolutions of the camera output and expresses them in terms of millions of pixels. Hence a camera producing a 2400 x 1600 picture would be a 3.8Mp camera.

Memory effect: The decrease of a rechargeable battery's power capacity over time.

Memory Stick: Sony's proprietary solid-state storage media.

Microsoft Windows 98/Me: A home user operating system for PCs. Now superseded by Windows XP.

Microsoft Windows NT: The Microsoft operating system designed for businesses using more secure file handling and access. Now outdated.

Microsoft Windows 2000: A Windows NT-based system used for businesses.

Microsoft Windows XP Home: The current direction of Windows. This version is based on the NT kernel but designed for home users.

Microsoft Windows XP Professional: A version of XP for home users, professionals, and small businesses.

Microdrive: A miniature hard drive offering large storage capacities that can be used in cameras with a CompactFlash Type II slot.

MultiMedia Card: A type of storage media used in digital devices.

Neutral Density (ND) filter: A filter that reduces the light coming into the camera for creative purposes. A graduated ND filter progresses from gray to white, thus affecting only the top or bottom of the image.

Ni-Cd or NiCad (Nickel Cadmium): A basic type of rechargeable battery. Can last for up to 1,000 charges, but may suffer from the memory effect. See also Memory effect.

NiMH (Nickel Metal Hydride): A rechargeable battery that contains twice the power of similar NiCad batteries. Also much less affected by the memory effect. See also Memory effect.

Optical viewfinder: A viewfinder that delivers an image of the scene either directly—or via mirrors—to the user, without recourse to electronics or an LCD.

Outputting: The process of printing an image or configuring it for display on the internet.

PC card: An expansion card interface, commonly used on laptop computers. A variety of PC cards offer everything from network interfaces and modems to holders for digital camera memory cards. Some memory card readers use PC card slots (or PCMCIA cards).

PC sync: A socket on a camera that allows the camera to control studio flash systems.

Pen tablet: An input device that replaces a mouse. Moving a pen over a specially designed tablet controls the cursor.

Photoshop: The industry-standard image-manipulation program produced by Adobe.

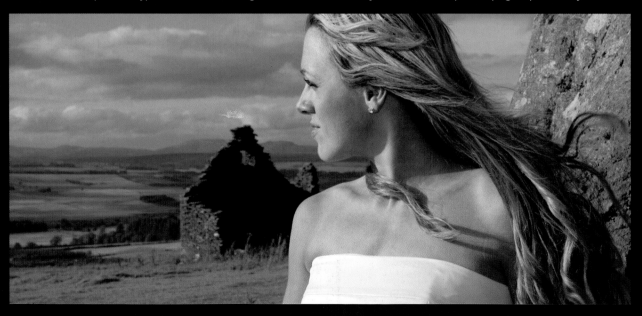

Pixel: A tiny square of digital data. The basis of all digital images.

Pixellation: The effect when individual pixels can be seen.

Plug-in: Software that integrates with a main photo-editing package to offer further functionality.

PNG (Portable Network Graphics): A file format commonly used for images on the internet. Can be defined in anything from 8-bit to 48-bit color.

Polarizer filter: A filter that blocks light waves at a specific orientation. Used to enhance skies and reflections or to block reflections.

Printer resolution: The density of the ink dots that a printer lays on paper to produce images. Usually expressed as dpi (dots per inch), but note that this is not the same thing as the dpi of an image.

RAW: A file format that records exactly what a camera's CCD/CMOS chip sees. The data is not altered by the camera's firmware (images are not sharpened, color saturation is not increased, and noise levels are not reduced).

RGB (Red, Green, Blue): The additive system of color filtration. Uses the combinations of red, green, and blue to recreate colors. The standard system in digital images. See also CMYK.

Secure Data (SD): A type of solid-state storage medium used in some digital cameras.

Shutter priority: A camera shooting mode. The user sets the camera's shutter speed, while the camera calculates the aperture setting.

SLR (Single Lens Reflex): A camera with the advantage that the image it shows through the optical viewfinder is the one that the camera sees through the lens. Digital SLRs are much faster, more responsive, and more powerful than compact digital cameras.

SmartMedia: A type of storage card used to store digital images. A very popular digital camera format, now replaced by x-D Picture Card format.

sRGB: A common, but limited color gamut, profile of the RGB system. Most commonly used in digital cameras. See also AdobeRGB.

Thumbnail: A small version of an image used for identifying, displaying, and cataloging images.

TIFF (Tagged Image File Format): A file format used to store high-quality images. Can use a lossless compression system to reduce file size, without causing a reduction in the quality of the image. Available on some digital cameras as an alternative to saving images using the JPEG format.

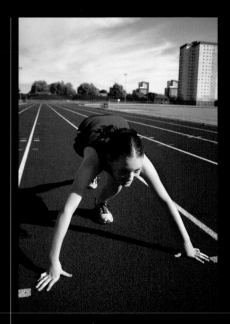

TTL (through-the-lens) metering: A sensor built into a camera's body that uses light coming through the lens to set the exposure.

USB 1.1 (Universal Serial Bus v1.1): An external computer to peripheral connection that supports data transfer rates of 1.5Mb/s. One USB 1.1 port can be connected to 127 peripherals.

USB 2.0 (Hi-speed USB): A variant of USB 1.1. Supports data connection rates of up to 60Mb/s. USB 2.0 devices can be used with USB 1.1 sockets (at a much reduced speed), and USB 1.1 devices can be used in USB 2.0 sockets.

VideoCD: The forerunner of the DVD video format, with a lower resolution than DVD video, but is used with standard CDs. Can be played on PCs.

WYSIWYG: "What you see is what you get". A term for a computer interface that outputs exactly what is seen on screen.

xD-Picture Card (xD Card): A memory card format that has been developed by Toshiba, Fujifilm, and Olympus. Designed as a replacement for SmartMedia.

X-sync: The fastest shutter speed at which a camera can synchronize with an electronic flash.

Zoom lens (optical zoom): A variable focal-length lens found on most cameras. Used to enlarge images. Compare with Digital zoom.

INDEX

ACKNOWLEDGMENTS

My thanks go to RotoVision for commissioning me to write this and to Chris for guiding this book along. I would also like to thank the featured photographers for permission to showcase their photos in the book —in particular Howard Dion.
DUNCAN EVANS, LRPS

RotoVision would like to thank Lizzie Patterson; Martha Evatt; Sophie Martin; Jason Keith; Suzi O'Keefe; Iain Gibbons; and Hiren for the use of his portfolio (© Hiren Chandarana 2005). All images are the copyright of the photographers.

HOWARD J. DION
Born in Philadelphia, Pennsylvania, in 1944, Howard photographs, processes, and prints 100% digitally. Howard lives with his wife Rebecca in Bucks County, Pennsylvania.
Hjayd@comcast.net

DAVID SAMS
David is a multimedia designer who lives and works in Glasgow, Scotland. He is studying black and white photography at the Glasgow School of Art.
david@seducedbyguadiness.co.uk
www.seducedbyguadiness.co.uk

JOHN PERISTIANY
John is based in Paris, France. He likes to take portraits as it involves interaction between the photographer and the subject, interpreting a moment in time.
Johnperi111@hotmail.com

ANDREW MAIDANIK
A resident of Toronto, Canada, Andrew mainly photographs people. He believes the most important aspect is creating a connection with the subject.
andrew@andrewmaidanik.com
www.andrewmaidanik.com

PAUL RAINS
Photography has been a joy of Paul's since childhood. Whether he is at home in the Ozarks or traveling, Paul enjoys taking photographs of nature and people.
prains@pol.net
www.paul.smugmug.com

LIZZIE PATTERSON
Lizzie began her career in London but her inspiration comes from Ireland. She studied at St. Martins and assisted photographers such as Sean Gleason and Sean Ellis. She has exhibited worldwide.
www.lizziepatterson.com

SIMON POLE
Simon was born in 1967 on the south coast of England, relocating to Scotland in 2002 where he produces fashion, portraiture, and landscape work.
info@simon-pole.co.uk
www.simon-pole.co.uk

KEVIN WYLLIE
Kevin got into photography to document his travels with the army, but now has a passion for portraits and glamor work.
kevin@kevinwyllie.com
www.kevinwyllie.com

MARTHA EVATT
Martha is a photographer who lives and works in Brighton, UK. She has studied the reinterpretation of Greek mythology in contemporary art and this influence is reflected in her most recent work.
martha@evatt.co.uk
www.flickr.com/photos/marthaevatt/

JASON KEITH
From West Cornwall and via Edinburgh, Scotland, Jason Keith now lives and works in Barcelona and specializes in fashion and portrait photography for editorial, advertising and design.
www.jasonkeithphoto.com

SOPHIE MARTIN
Sophie was born in Toulouse, France. After studying at the London College of Communication, she moved to Brighton, UK, where she photographs live bands.
zoemoonphotos@fastmail.fm

SUZI O'KEEFE
Suzi graduated from an Editorial Photography degree in 2004 and has created large bodies of work centered around experimenting with black and white portraits and self-portraiture.
suziokeefe@hotmail.com
www.edph04.com/okeefe.htm

CHRIS MIDDLETON
Ultra-high-speed monochrome portraits.
chris@darksome.net